For
Noya Brandt,
the members of the Dawson family
and the members of the Timothy family

ACKNOWLEDGEMENTS

We would express our thanks to the following people for their invaluable help with
the research and preparation of this book.

The Archives and Library, Cadbury Ltd; Dr. Mike Beazley, Centre for Urban and Regional Studies,
University of Birmingham; Mr David Bishop, Brian Gambles, Paul Hemmings and Brigitte Winsor,
Birmingham Central Library; Dennis Brandt; Noya Brandt; Susan Brandt; Peter Brandt; Bryn Campbell;
The Dawson Family; Dewi Lewis and Caroline Warhurst; Alastair Flint and Phillip Henslowe, Bournville
Village Trust; Mark Haworth-Booth, V&A; Michael Hallett; Nick Hedges; Christopher Timothy and
Margaret Timothy; Ian Jeffrey; John-Paul Kernot, Bill Brandt Archive; Sarah McDonald, Hulton Getty
Archive; William Muirhead; Ayshea Raphael and Jane Price, Arena, BBC; Nigel Warburton, Open
University; Cary Welling, Nottingham University.

We would also like to thank the Bill Brandt Archive and the Bournville Village Trust
for permission to reproduce the photographs, and The Centre for Urban and
Regional Studies (CURS) in the School of Public Policy at the University
of Birmingham for its support of this publication

First published in the UK in 2004 by
Dewi Lewis Publishing 8 Broomfield Road
Heaton Moor Stockport SK4 4ND
+44 (0)161 442 9450
www.dewilewispublishing.com

ISBN: 1-904587-07-0
Design & artwork production: Dewi Lewis Publishing
Print: EBS, Verona

HOMES FIT FOR HEROES
photographs by Bill Brandt 1939-1943

Peter James and Richard Sadler

Dewi Lewis Publishing

in association with

Birmingham Library Services

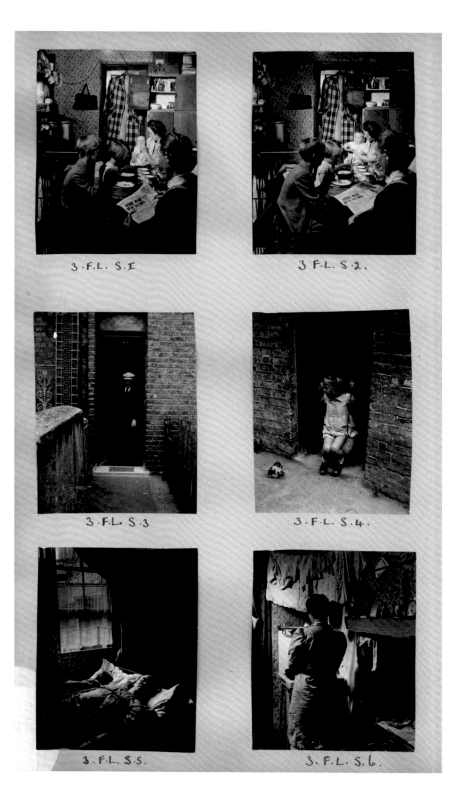

3 · F·L· S·I 3 · F·L· S·2.

3 · F·L· S·3 3 · F·L· S·4.

3 · F·L· S·5. 3 · F·L· S·6.

Page from the Bournville Village Trust Album

RECONSTRUCTION WORK

Bill Brandt's Photographs for the Bournville Village Trust, 1939-1943

Throughout the history of photography the camera has been used to provide visual evidence in polemical essays, reformatory texts, government and local authority reports, and charitable campaigns, particularly those which sought to improve housing, sanitation and the general conditions of the working classes. Although less well-known than the work of John Thompson, Thomas Annan, Lewis Hine, Jacob A. Riis, Walker Evans or W. Eugene Smith, these photographs by Bill Brandt form part of that history. Originally taken between 1939 and 1943 they did not come to the attention of the photographic world until the mid 1990s[1] when they formed the centre-piece of an exhibition – complimented by a series of lectures and a one day symposium – held at Birmingham Central Library [2]. Given Brandt's fame and his considerable influence on the development of modern photography it seems odd that they lay unknown for some fifty years. This essay seeks to offer some explanation; to build up a picture of how, why and where they were taken; and from this to develop some understanding of what they tell us about Brandt and his photography.

It is well recorded that in the 1960s and 1970s Bill Brandt sought, "through the judicious retro-spective selection of his pictures, most of which had been originally taken for magazines", to control "the body of work by which he was to be recognised as a photographic artist"[3]. This process is not unique to Brandt as an individual, or to photography as a medium. Painters, writers, historians, architects and even planners, famous and not-so-famous, have all manifested desires and made decisions about how they wish to be viewed by posterity [4], though the methods and materials they choose as the vehicle for this process may vary. For example, Sir Benjamin Stone, the noted Birmingham record and survey photographer, handed down a collection of some 22,000 prints which includes double exposures and others in which his camera bag, hat and umbrella frequently, though unintentionally, become additional points of historical interest. Alongside the visual evidence of his achievements Stone also collected over fifty volumes of press cuttings about himself and his work, invitations to social events, as well as diaries and a host of other related ephemera[5].

Stone seems to have taken every available opportunity to give interviews and then collect the resulting cuttings about his activities, whereas Brandt was famously reticent with regard to speaking about his life and work[6]. He did not mention these images in any recorded public statement or in any of the few interviews that he gave. That they came to light in Birmingham, rather than in the Brandt Archive, the V&A, the Hulton Getty Archive or any of the other well-known sources of his material, further suggests that they did not form part of Brandt's self-established artistic canon. It is perhaps for these reasons that the photographs remained hidden for so long and why their story is still shrouded in some mystery.

Whilst acknowledging that Brandt had his own entirely valid personal reasons for re-editing and reprinting his earlier work, this does not mean that we should dismiss these images. For like writer's drafts, historian's revisions, and planner's mistakes, we can often learn as much from looking at what the producer may choose to ignore as we can by exploring their greatest successes. Here as elsewhere[7], little-known bodies of work by Brandt reveal the presence of his obsessions and shed light on the working methods adopted in his commercial assignments[8]. At the very least the fact that he chose to leave negatives and prints with the commissioning agent, whilst retaining or re-claiming others provides an insight into his editorial processes.

The story of the re-discovery begins in the late 1970s when Caroline Welling, then a lecturer in photography at Derby College of Art and Design and a resident on the famous Bournville Estate, saw the material. Welling brought it to the

attention of Richard Sadler, Senior Lecturer in Photography at Derby. Some time later, when Ansel Adams introduced Sadler to Brandt and to their mutual friend Brassai at the opening of his 1976 exhibition at the V&A, the two found much in common. In their youth both had spent time in a sanatorium whilst being treated for TB and therefore shared a similar experience – long periods spent getting to know every detail of the rooms in which they were confined, an awareness of the importance of light and fresh air in the treatment of their illness – as well as shared interests in portraiture and the nude[9]. These common bonds led to Brandt extending an invitation to Sadler to visit him at home so that they could continue their dialogues about photography. They subsequently met on a number of occasions between 1976 and 1980 and it was during one of these meetings that Sadler asked about these photographs. Brandt responded with typical simplicity: it was just "a job well done".

Some years after Brandt's death in 1983 a retired architect, William Muirhead, began cataloguing photographs in the Bournville Village Trust (BVT) archive, then held at the Estate Office in Birmingham. Amongst the items that caught his attention were a set of sixty-six, two and a quarter inch square negatives stored in paper sleeves and a series of seventy-two enlargements, the majority of which corresponded to the negatives. Muirhead latterly recalled filing and indexing both negatives and prints, making particular note where a negative was "missing"[10]. Although he made a series of enquiries it seems that Muirhead was unable to uncover any information about the pictures.

The story then leaps forward a decade to the latter half of 1993 when the BVT deposited their records with the Archives Department at Birmingham Central Library[11]. Around the same time Richard Sadler mentioned their existence to me. An animated search soon located both negatives and prints. This re-discovery came at both an exciting and pertinent time, for it was then that Bogle, Bartle, and Hegarty were using Brandt's famous nudes in an advertising campaign for Levi jeans and Ian Jeffrey was completing work on the Brandt retrospective shown at the Barbican in 1993. Jeffrey suggested that it would

"be very interesting to see them published" as he previously "thought of Brandt groups being found in the Imperial War Museum, Hulton Deutsch and the National Monuments Record"[12].

The seventy-seven enlargements, probably made for the reference of the photographer and the commissioning agent, are mounted in a maroon-coloured loose-leaf album. Unfortunately Muirhead did not divulge whether he, Brandt or some other person pasted them into this album in the sequence that they now appear. For what it is worth the album itself certainly seems to pre-date the period in the 1970s when Muirhead was working on the material. The enlarged prints range in size from 5.5 x 6.5 cms to 11 x 9.5 cms. Comparison with the corresponding negatives indicates that most of these have been cropped from the negative's original square format and this perhaps suggests how Brandt envisaged them eventually being printed as photographs or reproduced in published form[13].

Within the album's pages the prints are laid out in six distinct groups consisting of a mixture of double and single page spreads: the largest group comprises sixteen prints and the smallest just four. Although not laid out in a precise chronological sequence on each page, it is clear that three of the groups follow a distinct narrative progression tracing a day in the life of the families photographed. Indeed it seems somewhat incongruous that the arrangement of prints on the page and the index sequence in all but four of the series do not appear to follow what we might now think to be this narrative progression. The remaining pages seem to comprise sets of complimentary images showing street scenes with people gathered outside shops, children playing, claustrophobic views into slum courtyards and a short sequence showing domestic arrangements in a modern municipal house. The two pages bearing the prints beneath which Muirhead's wrote "missing negative" are largely made up of these images. The negatives and related prints from this sequence and other images from this project are held in the Bill Brandt Archive.

Taken together, this collection of short photo-stories and complimentary images clearly seeks to depict and contrast living conditions in a range of

housing types – from inner-city back-to-back and tunnel-back slums originally built in the nineteenth century to modern municipal houses built in the 1930s. The photographs in five of the six groups were taken in Birmingham. A combination of research and information given by visitors to the exhibition helped identify all the Birmingham locations and in two instances, the families who appear in the images (See *Bill Brandt Took My Picture*). The markedly different housing stock appearing in the final sequence suggested that they were taken elsewhere. A search for the shop shown in one image (3.F.L.S.14) in *Kelly's Directory* for London for the war years gave its location as 158 Malden Road, North London, not far from Brandt's Hampstead flat.

All of the larger narrative sequences contain images that highlight key issues relating to the design, construction and location of housing: light, ventilation, space in and around the home, recreation, the proximity to shops, the preparation and consumption of food, the journey to work, and sleeping arrangements. Many of these were taken to build up a series of direct contrasts between the environment and quality of life enjoyed by the inhabitants. In making a set of enlarged exhibition prints Richard Sadler discovered vital evidence that reveals how Brandt manipulated the composition and lighting within key pictures to intensify the atmosphere within individual images and the contrasts between sequences (See *Bill Brandt on Assignment*). For example, in the slum interiors curtains are drawn, artificial lighting is used and Brandt works from tight, claustrophobic viewpoints. There is more space between Brandt and the figures in the modern houses and he also creates a greater sense of light and room in these interiors, with windows commonly thrown open to allow air and sunlight to flood in from the countryside beyond. Taken together, the combination of subject matter and Brandt's chosen manner of representation leave the viewer with little doubt about the propositions being put forward through the pictures.

Bill Brandt frequently used similar narrative and comparative devices in the books and photo-stories published in the 1930s and 40s. For example, the use of a narrative sequence defines the structure of four of his *Picture Post* essays including 'Nippy, a day in the life of a waitress at a Lyon's Corner House, London' (4 March 1939) and 'The Perfect Parlourmaid' (29 July 1939). Narrative patterns like this were established in the German illustrated press of the 1930s and then carried over to England by pioneering picture editors such as Stefan Lorant who established them as regular features in magazines such as *Weekly Illustrated* and then *Picture Post*[14]. Similarly, the interrelationship of images to highlight social contrasts was one of the devices famously used by Brandt in laying out his pictures in his first two books *The English at Home* (1936) and *A Night in London* (1938)[15]. It is interesting to note that many of Brandt's contemporaries saw the images in these two books as "documentary polemics against social injustice and poverty"[16]. Brandt, however, denied that these were in any way political images, countering these interpretations by stating that he was actually "inspired to take these pictures because the social contrast of the 'thirties was visually very exciting"[17].

Further evidence of Brandt's adoption of previous visual strategies is revealed in individual images, such as that of the woman cleaning a bath (3.F.W.5) and the published image of the aforementioned parlour maid undertaking a similar task. Interestingly, given that both images appear to have been taken in 1939, there perhaps remains the question of which came first. Echoes of other earlier images appear throughout the album: for example the images of evening meals in London (3.F.L.S. 1 & 2) and Birmingham (3.F.S.6 & 7) and that of a Northumbrian miner at his evening meal, taken in 1937. Here also one can conceivably see a relationship between the image of the man and child (3.F.S.7) and that of a mother and her children taken in London in the 1930s that appears on the back cover of *The English at Home* in the way that Brandt directs the viewers' attention through the gloom to the face of the child which thus becomes the focal point of the image. Although less in number, there are also suggestions of compositional relationships with some later images. For instance, the arrangement of objects on a table around which a family sits in a Birmingham slum (3.F.S.7) and those featured in his untitled nude of 1945[18] are remarkably similar: the bottles of milk, glass dish, and sandwich that occupy the foreground space in the earlier picture have been replaced by a wine

bottle, a soda siphon, a plate with cheese and a bowl of fruit[19]. Brandt explained something of this experimental process in his book *Camera in London*, published shortly after the war. In this he described how he attempted to convey "atmosphere by intensifying the elements that compose it" admitting that this was "a hit and miss process". He wrote: "I would produce an effective picture, photographed and printed, I believed, in my usual way. Taking thought, I would try and reproduce the same effects with another subject and fail completely. Learning by trial and error, I now know how to sharpen my effects"[20].

This is neither remarkable in itself nor something that is somehow unique to Brandt. It is something that all photographers and artists do as part of their creative development. Indeed it is perhaps only the imposition by others of the term 'documentary' – with all its modern associations of truth and objectivity – onto his work for the illustrated press that makes the engagement of such strategies appear at odds with their perceived – rather than their stated – purpose. The notion of Brandt's images as so-called "documentary fictions" and questions relating to "authenticity" of his work, have been dealt with at length by other writers[21]. Nonetheless, the very fact that Brandt's work was published in *Picture Post*, led to it being read as being documentary in nature. Seen in this context his images certainly appear to fulfil the objective requirements of this mode of practice. Although we now know that Brandt was equally, if not more engaged in personal picture-making during such assignments, he was unlikely to make mention of this to Lorant, Hopkinson or any other picture editors as this might have led to them ceasing to use his work, with the knock-on effect that a significant source of income simply dried up. And perhaps this in turn goes some way to explaining his reticence. It was perhaps not so much a case of wilful mystery as economic practicality. You can imagine that his surrealist tendencies might also have been quietly amused by the thought of this 'unreal', constructed work being published and read as authentic. In 1948 Brandt himself, in a perhaps unknowingly prophetic fashion wrote: "…what we see is often only what our prejudices tell us to expect or see, or what our past experiences tell us should be seen, or what our desires want to see"[22].

Having thus gained some understanding of Brandt's approach to producing this body of work the question remains as to why he actually took these pictures. Writing in 1948 Brandt explained that he hardly ever took photographs "except on an assignment"[23]. In 1976 his friend, Norman Hall, former picture editor of *The Times*, wrote that "Whenever he takes a camera away from London it is because he has been commissioned to do so"[24]. It therefore seems reasonable to suggest that these pictures formed part of an assignment for the Bournville Village Trust. But what evidence beyond the existence of the album and the location of its re-discovery is there to support this?

The Trust set up by George Cadbury in 1900 was formed to manage the Bournville Estate, the model housing development which he created near his factory on the outskirts of Birmingham[25]. The objects of the Trust included the amelioration of the conditions of the working class population of Birmingham and elsewhere in Great Britain. Cadbury became a pioneer of town planning and his work on the Bournville Estate became a model of "how working people could be housed in pleasant and healthy surroundings, without being the objects of philanthropy, and how the evils he had encountered in nineteenth century Birmingham could be avoided"[26].

The Minutes of the BVT Quarterly Meeting for 20 March 1937 reveal one way in which the Trust sought to pursue these objectives. They included a note of a "report on a suggested programme of research into matters affecting the re-planning of the City of Birmingham…an investigation into the housing needs of the Central Areas to ascertain the number of families which ought to be housed there, open spaces, re-housing etc"[27]. The Minutes of subsequent meetings chart the manner in which this proposal developed into a full-blown scheme of practical work and the creation of a Research Department set up under the leadership of the Trust's Research Architect, C.B. Parkes, to carry out the investigation. By January 1939 the research was complete. Paul Cadbury then suggested "that a well illustrated and attractively drawn up book should be prepared based on the results of the research…with advice from Cadbury's Advertising Department", under the direction of P.B. Redmayne[28]. The proposal was

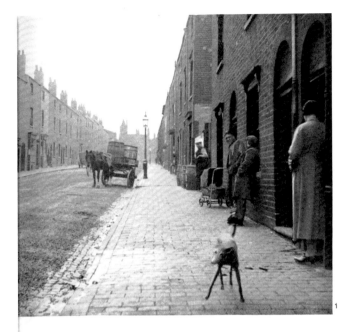

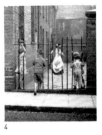

The children usually play in the courtyards or streets.

Birmingham's Central Wards

Back-to-back houses are the most typical feature of Birmingham's Central Wards. The houses often consist of three rooms, one above the other. The living rooms open directly on to the street or court (for typical plans see page 34). These views show (1) a typical street, (2) a living room opening on to the court, (3) the court itself. Such houses now let at an inclusive rental of about 8s. per week (see page 58).

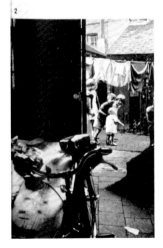

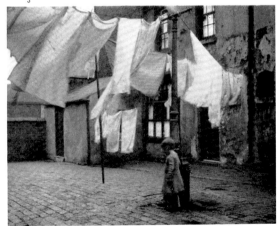

'Birmingham's Central Wards', When We Build Again, Bournville Village Trust, 1941, p. xiii.

WHEN WE BUILD AGAIN WE MUS

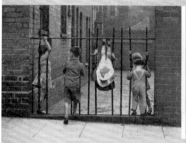

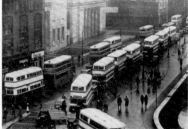

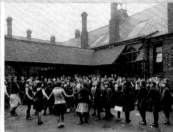

No more playgrounds like this **No more congested streets** **No more overcrowded schools**

BUT CREATE A CITY OF WHICH OUR

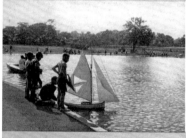

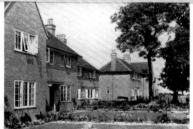

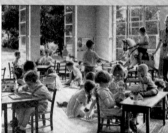

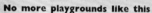

With more green play parks **With healthier houses** **With sunny airy schoolrooms**

'Birmingham to-day, A Comparison of the Central Wards and Outer Ring', Our Birmingham, Cadbury Brothers, 1943, p.38-39. Birmingham Central Library.

accepted and a Minute from a subsequent meeting reported that "P.B. Redmayne is providing the photographs"[29].

The BVT were not the first, nor by any means the only organisation aware of the social problems associated with poor housing in general, those experienced by the second largest city in England in particular, and of the potential use of photography as a weapon to affect its causes. As early as 1875 Joseph Chamberlain, regarded by many as the founder of so-called Municipal Socialism, grasped the magnitude of the task of slum clearance which faced Birmingham's council. He initiated a bold plan under the Artisan's Dwelling Act to clear away the insanitary inner-city slums and the Improvement Committee commissioned James Burgoyne, photographer from Small Heath, to record the slums and commercial properties prior to their removal.

Burgoyne's labours resulted in the production of one hundred and thirty-nine large sepia-toned albumen prints that provide us with a remarkable record of these areas [30]. Thirty years later Birmingham still had major problems resulting from the living conditions in its slum properties. The BVT undertook work to refurbish slums for the Birmingham Copec House Improvement Society Ltd., by renovating properties and removing walls to allow light and air into the cramped courtyards. Here again a local photographer was employed to record the entire process[31].

Further afield, in November 1934 the Weekly Illustrated carried a polemical article under the title 'Pull Down the Slums' [32]. Photographs were used to great effect in George Orwell's The Road to Wigan Pier and Wal Hannington's The Problems of the Distressed Areas, both published in 1937 [33] and in November January 1939, Picture Post ran a

NOT REPEAT OUR OLD MISTAKES –

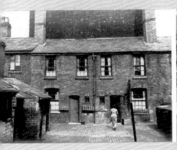
No more dingy courts

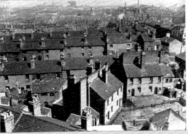
No more drab districts

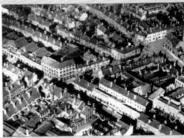
No more huddled houses

49

GRANDCHILDREN WILL BE PROUD

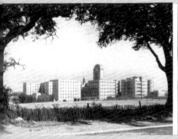
With fine hospitals

With better factories

With good gardens

feature about Birmingham illustrated with photographs by Humphrey Spender, a member of the reformist group Mass Observation[34]. In the accompanying essay Harold King noted that "Birmingham is a city of contrasts, where affluence jostles with abject poverty. It has forty-thousand back-to-back houses, and 48,000 municipal dwellings – the largest community-owned estate in the kingdom"[35]. He went on to describe how, despite the best efforts of civic leaders like Joseph and Austin Chamberlain, there were areas where "some forty-thousand souls still drag out a mainly drab existence" and although this number was decreasing, it was "strange how some of the older residents still cling to their hovels, and resent any effort to transport them to the brighter surroundings, far from the chimney stacks and the fumes of the factories"[36]. Three months later *Picture Post* published 'Enough of All This!'[37], a picture story described as "an impassioned polemic against the evils of poor housing and poverty in London"[38]. This was illustrated with photographs by Bill Brandt. Given the magazine's widespread distribution and its active engagement with the issues that concerned the BVT, it is easy to see how Redmayne may have viewed Brandt's images, and the visual strategies employed by Stefan Lorant in presenting them, as being ideally suited to their own project. The sequence of images in the Bournville album certainly appears to have been taken with precisely these kinds of issues and visual strategies in mind.

Although preparatory work on the BVT book was complete by 1939, the outbreak of the Second World War delayed its publication until 1941. When it finally reached the bookshops it contained a 'Foreword' by Lord Balfour of Burleigh that declared: "To-day, save for the successful prosecution of the war, no subject is so much in the

public mind as reconstruction. During the last war most people took it for granted that a better world would emerge almost automatically from victory. Hardly anyone doubted that Homes For Heroes and all that that phrase stood for would be achieved. This time we know better, and we realise that the defeat of Germany is not enough in itself to secure a perfect world. We have also, thanks to the German bombers, a much greater opportunity for physical reconstruction"[39].

Burleigh's comments display how the outbreak of hostilities served to remind people of the failure to implement the planned social improvements, including the building of 'Homes for Heroes' after the First World War[40]. *When We Build Again*, the title chosen for the BVT book, also gave a clear signal that although their work originally had a specifically local remit, their conclusions were now firmly placed within the wider context of Post-War Reconstruction. The text was illustrated with a series of colourful maps, diagrams and tables and most significantly in this context, forty-two photographs contrasting housing within Birmingham's inner, middle and outer ring districts. Although no individual photographers are specifically credited in the *Acknowledgements*[41], the degree to which some of the images represent thematic, compositional and juxtapositional parallels with those in the BVT album, and with other known images by Brandt, suggest that he may have been responsible for some of these photographs.

Whilst *When We Build Again*[42] proved to be a great success, and was re-printed a number of times, its audience appears to have been primarily professionals, civic employees and academics involved in planning. The problem of how to raise these debates amongst the general public remained. Perhaps encouraged by an article written by Paul Rotha[43] in 1941, which hailed film "with its many unique devices of animated models, diagrams, and map work, with its power for argument and discussion in the sound track, with its simple yet persuasive powers of explanations" as a "medium unequalled for spreading information by a multiplicity of showing"[44], the Bournville Village Trust set about making another version of *When We Build Again*. The finished film – which included a commentary in part written and performed by Dylan Thomas, who had been photographed by

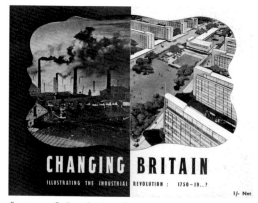

Front cover, Cadbury Brothers, Changing Britain,
Illustrating The Industrial Revolution: 1750-19..?, July 1943.
Bournville Village Trust Archive, Birmingham Central Library.

Brandt around 1941[45] – was hailed as "the first made in Britain to present some of the basic issues of town planning to the public"[46]. Copies were made available to the Ministry of Information for group showings up and down the country.

The film included sequences exploring a model town that had been specially designed for the purpose by Mr Thomas Sharp[47]. This model formed the centrepiece of a touring exhibition "designed to *interest the layman*" produced by the BVT and Town and Country Planning Association in 1943[48]. In April that year *Picture Post* published an article by the Archbishop of York in which he argued for the church's vital role in the political, social and economic issues of planning a Post-War Reconstruction. This was illustrated with a photograph by Bill Brandt showing the Archbishop studying the same model[49].

Having first applied their "new visual method to the presentation of statistical and other information" in *When We Build Again*, in April 1943 Cadbury Brothers published two further books: *Our Birmingham*[50], which presented facts about housing and social issues to pupils in locals schools, and *Changing Britain, Illustrating the Industrial Revolution: 1750-19..?*,[51], both priced at one shilling[52]. *Our Birmingham* included photographs published in *When We Build Again*[53] and others showing distinct thematic and compositional similarities to those in the BVT album. Like Brandt's cover for *The English at Home*, Redmayne employed the visual scheme of contrasts, juxtaposing a photograph of a grimy inner city area with that of

a plan for a modern housing estate on its cover. P.B. Redmayne also used this format for the cover of *Changing Britain*, using factories old and new on the front and housing estates and their physical relationship to factories, again old and new, on the back [54]. But most significant in this context is the reference to Bill Brandt amongst the 'Acknowledgements'. Brandt's pictures appear in the section on housing under the heading 'Houses of the Industrial Revolution…Many Are Still With Us'. On page 22, directly opposite the first four photographs in this section, Redmayne reproduced Gustave Doré's engraving of the slums of London. Once again he was borrowing from the design ideas of Stefan Lorant because this engraving appeared in exactly the same kind of juxtaposition as that used by the then editor in the *Lilliput* feature 'Unchanging London' published

child and stretching cat in a Sheffield slum court [56] appears – seemingly reversed – in a sequence on the cover of the Winter edition of *Town and Country Planning* 1942-43. This image was also reproduced in both editions of *Shadow of Light* [57]. The photographs on the following pages similarly parallel the subject matter, composition and narrative structure of images in the Bournville album.

These BVT publications were just part of a more widespread literature dealing with the issues of Post-War Reconstruction. Throughout the early 1940s, initially under the guidance of Stefan Lorant and – from July 1940 – Tom Hopkinson, *Picture Post* ran a series of articles and special editions on the subject, some of which included pictures by Bill Brandt [58]. In January 1941 the whole edition was

HOUSES OF THE INDUSTRIAL REVOLUTION

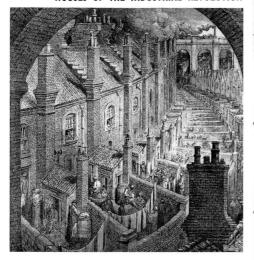

. . . MANY ARE STILL WITH US

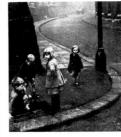
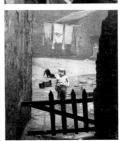

'Houses of the Industrial Revolution? Many Are Still With Us', Cadbury Brothers, Changing Britain, Illustrating The Industrial Revolution: 1750-19...?, July, 1943, p22-23. Bournville Village Trust Archive, Birmingham Central Library.

in 1939 [55]. The accompanying commentary in *Lilliput* noted that "like Doré, Bill Brandt has the art of infusing realism with a sense of beauty". As for Brandt's photographs, one, the view beyond a kitchen table and into a courtyard, also appeared in *When We Build Again*, *Our Birmingham* and another BVT publication, *Sixty Years of Planning, The Bournville Experiment*, published in 1942. The image of children playing on a street corner, taken in London in the 1930s, is certainly amongst those held in the Brandt Archive. And the image of a

devoted to 'A Plan For Britain'. Above the caption 'The Unplanned Kitchen', Hopkinson published a variant of Brandt's famous image of a mother washing clothes in a metal tub, whilst her baby lies on a cushion in front of the range. A circular, cropped version of the *Picture Post* image was used to similar effect in *The Daily Mail Book of Post-War Homes* [59]. Over twenty years later Brandt published his preferred version of this image in both editions of *Shadow of Light* under the title 'A Sheffield Kitchen'. But perhaps the most fascinating

article in *Picture Post* that relates to the BVT album was published on 1 January 1941. In a special edition examining 'The Present and Future of a Valley in Wales', Tom Hopkinson set out on opposing pages words and pictures contrasting 'What it Means to Live in a Good House' and 'What it Means to Live in a Not-so-Good House'. These follow the structure of the images in the BVT album. Indeed the text could well have been written to accompany Brandt's pictures:

"The Leslie Owens live in a cramped, old-fashioned house. They have only four rooms, no bathroom, no hot water, no garden… The rooms in the room for Father and Mother to have a bedroom to themselves — a rarity in overcrowded districts. There's room for the girls to entertain in one room while Dad and Mother read or work in peace in another. There's somewhere to cook in comfort. There's somewhere to get clean. There's somewhere for the children to play outdoors in absolute safety."

Sarah McDonald, Curator at the Hulton Getty Archive reveals that the photographs of a "Good House" were in fact taken by another German émigré, Kurt Hübschmann, and those of the "Not-So-Good-House" by Hayward Magee. It is

HOW HOUSING HAS CHANGED　　**IN THE PAST 100 YEARS**

'How Housing Has Changed in the Past 100 Years', Cadbury Brothers, Changing Britain, Illustrating The Industrial Revolution: 1750-19..?, July 1943, p.24-25. Bournville Village Trust Archive, Birmingham Central Library

house are very small; the light poor for reading or sewing. Although their rent is 9s.4d., a bathroom is a luxury to dream about. The lavatory is outside in the yard. The only place for the children to play is under the string of washing in the tiny yard; for there's no garden and only a busy, traffic-laden road outside."

"The David Davieses live on a modern housing estate. They have good rooms, enough of them, a bathroom and a garden… a parlour, (which can be used as a spare bedroom), three upstairs bedrooms, a bathroom, a fair-sized kitchen, and a piece of garden, for the rent of 13s.7d. There's

interesting to note that she also found amongst the contact sheets for this story that "additional material by Felix Man, Leonard McCombe and some two and a quarter inch square views of a colliery in Wales by Bill Brandt"[60].

Picture Post was by no means the only publication to address these issues, indeed there was an abundance of literature produced by the Royal Institute of British Architects (RIBA), Mass Observation, The Architectural Press, The Council and the British Institute of Adult Education, The Pilot Press, and the Town and Country Planning Association amongst others, some of which

related to touring exhibitions, dealing with issues of Post-War Planning. Many of these also drew to a significant extent on the visual vocabulary of *Picture Post* [61]. Some may even include images by Bill Brandt.

It should not be forgotten that Brandt also undertook a number of other assignments outside the realms of his published work during the Second World War. Ian Jeffrey describes these assignments – photographing air-raid shelters in the Blitz for the Ministry of Defence in 1940 and photographing monuments in various English cathedrals and churches as a record against possible bomb damage for the newly formed National Buildings Record between 1941 and 1943 – as "a sort of National Service"[62]. Writing about the aid-raid shelter photographs, Rupert Martin suggested that Brandt "portrayed the vulnerability of people sleeping, and conveys something of the suffocating atmosphere of the Underground"[63]. There is a similar sense of vulnerability in some of the sleeping images that Brandt made in Birmingham (3.F.S.8) and London (3.F.L.S.5) in 1943. The Birmingham images also contain visual evidence of the threat to life from bombing through the presence of an Andersen Shelter in the back garden (3.F.S. 1 and 2) and the white patches painted on the entrance to doors and alleyways, put there to help people navigate during the blackout. The proximity of these homes to nearby factories, originally an issue in relation to the health of their occupants, now placed them in danger of bombing. Further evidence of this threat can be seen through the presence of buckets of sand hung outside houses to extinguish incendiary devices, in the image of children playing in the street (B.S.3).

In the same essay Martin also notes that "Bill Brandt trained as an architect" and that "his interest in architecture was put to good use in the commission he received from the National Monuments Record". Nigel Warburton suggests that the cathedrals photographed by Brandt during this assignment had great symbolic importance during wartime for they represented a "sense of continuity with the past", and, like the Tower of London, held a symbolic importance that was of great importance to national morale during wartime[64]. Brandt's knowledge of architecture and its close association to issues of Town Planning may have been one of the factors that led the Bournville Village Trust to engage him on their project. That same knowledge may similarly have provided Brandt with a personal interest in carrying out the assignment. The project may also have interested him because of the BVT's links to the Town and Country Planning Association, which, under the guidance of its founder, Sir Ebernezer Howard, was at the forefront of a Garden City Movement that sought to make a dream of England into reality.

Brandt's spells of photographic National Service may have also served a variety of practical purposes beyond getting paid work and gaining access to photographic materials in a time of austerity and heightened security [65]. Some German photographers such as Kurt Hübschmann, who, like Brandt had chosen to leave Germany and settle in England (he anglicised his name to Kurt Hutton) were interned on the Isle of Man for part of the war. As Ian Jeffrey suggests "as a documentarist with a taste for mist and darkness" Brandt might have "easily been taken for a suspicious person, especially with a German accent"[66]. By under-taking these assignments Brandt was able not only to continue working throughout the war, he could also be seen to be making a positive contribution to the war effort. Furthermore, by working for the BVT he was granted legitimate access to houses and rooms in the dark centre of a city, and to another dimension of the contrasts in English social life that so fascinated him. He was therefore able to indulge his personal interests and pursue the creative development that would eventually result in the two editions of *Shadow of Light*; the work by which he wished to be known as an artist, and get paid for the pleasure of doing it [67].

By 1945, the year in which he purchased his famous Kodak Wide Angle cameras in Covent Garden, Brandt's photographic interests were beginning to lie elsewhere. He was, nonetheless, still supplying images to illustrate articles on post-war planning. For example two images relating to the BVT album appeared in an article about 'Glasgow's Housing Problems' in *Town and Country Planning* in the summer of that year[68]. He did not publish his famous photographs of the Gorbals for *Picture Post* until 1948.

In the years after the war Bill Brandt began making, publishing and exhibiting the portraits, nudes, and landscapes upon which, as Nigel Warburton suggests, "the public perception of Bill Brandt is largely based on …a few hundred photographs which have been reproduced again and again, principally the images in the second edition of *Shadow of Light* (1977)"[69]. When, in 1994, the news of the re-discovery of the BVT album reached the photographic press, Mark Haworth-Booth, speaking to the *British Journal of Photography*, said that "Brandt was an extremely good editor of his own work and if these photos were never included in any of his books then perhaps he did not rate them and his judgement should be taken into account"[70]. This book and the exhibition that preceded it have always sought to respect that imperative. Nonetheless, the handful of people who have helped develop the ideas and information in relation to the vital questions about the images themselves (the context in which they were produced, the manner in which they were meant to be viewed, and the audience they were aimed at) have felt equally strongly that they should not be simply dismissed as marginalia. We now know a great deal more factual information about the pictures and the context in which they were produced. We know that between 1939 and 1943 Bill Brandt undertook an assignment to produce and provide images to the Bournville Village Trust to be used by them in a series of publications addressing the issues of housing and Post-War Reconstruction. In pursuit of this objective Brandt travelled to Birmingham on more than one occasion, making a series of visually and thematically related images in slums and new municipal estates, and in properties near his London home. Some of these were used in these publications and others were not. He also supplied the BVT with images from other earlier assignments to illustrate these issues. Brandt made editorial decisions about which images he wanted to be used, and possibly how, and other decisions about which he wanted to retain for himself and which he was happy for the BVT to keep. Furthermore, it seems apparent that in completing this assignment Brandt not only drew upon and sought to develop visual strategies from earlier work, but that he also began exploring ways of depicting figures and the space within rooms that would re-appear in some of his later pictures. We also know that Brandt supplied images illustrating articles on Post-War Reconstruction to a range of publications and that many of those responsible for publishing these and other related works drew heavily on the visual language of the popular illustrated press to convey their message to a wide public audience. Yet even when making work to fulfil the polemic objectives of popular publications and campaigning reformist groups such as the BVT, Brandt made images which explore and reveal many of the "obsessions" for which he subsequently became famous: the atmosphere of rooms, the darkness and mystery of the city; and sleep and dreams. The photographs he produced during this assignment reveal how Brandt, influenced by the cinematic lighting schemes of the period, manipulated composition and lighting, thereby simultaneously intensifying the strength of the arguments being put forward by the commissioning agents and the atmosphere within the pictures that he made for his own purposes.

And yet some questions remain unanswered. Were the problems that later generations of critics and writers raised about the documentary authenticity of his work an issue for the photographer himself? Apparently not. Brandt appears to have taken the opportunities that the assignment presented to make a series of images, some of which, whilst containing some simplistic symbolic elements e.g. the representation of the child as the hope for the future, do not go far beyond the surface representation of the situations and moments that were presented to him. However, when he saw or sensed the opportunity to go further, he skilfully manipulated some of the elements before his camera and made images that sought to go beyond the referential. Although he never lost sight of the requirement of the assignment, he made images in which the public's need for information and his personal desire to make pictures coexist side by side. The notion of an image that can at one and the same time be both pictorial and 'documentary' is nothing new. For example, many of the photographers contributing to record and survey projects such as the National Photographic Record Association[71], either side of the turn of the nineteenth century, made work that could, within the boundary of a single frame, or in a series of images drawn from

the same subject, meet what were perceived by many to be the conflicting needs of commerce, evidence and aesthetics. Whilst developing his own distinct way of working, Brandt can also be seen to be following a path begun by others: a path that led to such diverse evolutionary developments as the work of Mass Observation and the photographs of Tony Ray Jones. But that is another story. However, what Brandt seems to have grasped in fulfilling the requirements of this and other assignments with similar didactic objectives was that, as Jonathan Jones wrote in a recent article about the famous surrealist film *Un Chien Andalou,* "to tell a story on screen", or in this case on a printed page, "you create a physical world that serves your purpose"[72].

One other outstanding question remains. Why did the Bournville Village Trust not use these pictures? At the time of writing there is insufficient evidence to offer anything more than some speculative ideas. Perhaps the BVT did not feel that these particular pictures fulfilled their objects. Equally, it is possible that Brandt may not have been happy with the way in which the BVT proposed to use them, having set them out himself within the pages of the album. Perhaps we will never know, and that might be just how Bill Brandt would have liked it to remain.

Although Brandt saw it simply as "a job well done", the pictures in the BVT album were taken at a pivotal point in his career. They tell us a great deal about the photographer and his methods, and these revelations in turn tell us a great deal about the use of photographs, graphics and design in the context of Post-War Reconstruction. Although these photographs are by no means the most significant images that Brandt produced during his career, here as elsewhere there is ample evidence to suggest that Brandt's photography is work "constructed by an artist"[73].

Peter James, February 2004

Postscript

The BVT's pioneering work, dealing with post-war reconstruction and town planning, carried on after the war, and this work was again the subject of a series of landmark publications, each illustrated with photographs, maps, and charts. These influential works include *Conurbation*[74] and Paul Cadbury's book, *Birmingham Fifty Years On*[75]. This latter work retained and developed the device of visual contrasts, juxtaposing nineteenth century prospects and photographs of Birmingham with contemporary photographic views of the city, and taking things further still, a series of photographic views taken in 1952 with artist's impressions of the same streets in the year 2002.

Issues surrounding housing, reconstruction and regeneration were, and continue to be, sites of engagement for a diverse range of documentary projects for photographers in Birmingham. In 1967, Nick Hedges, then a student at the Birmingham School of Photography, followed in Brandt's footsteps, undertaking a project for the Birmingham Housing Trust. He subsequently went on to work as a photographer for the housing campaign group, Shelter[76]. Hedge's photographs of housing conditions in Birmingham and in other British cities reveal in stark detail that in the mid 1970s, despite the positive and important contributions of the Bournville Village Trust and other campaigning and reformist groups, the promise of a 'New Jerusalem' after the Second World War, had, for many, failed to materialise. Thousands of people were still living in conditions almost exactly the same as those depicted in Brandt's photographs of the 1930s and 1940s[77].

THE PHOTOGRAPHS

The photographs that form the core of this book have been reproduced
from a series of exhibition prints made from Brandt's original negatives by
Richard Sadler in 1993. They have been cropped to omit markings made
by William Muirhead at the Bournville Village Trust when indexing them
in the 1970s. The aim in presenting them is not to suggest that that
they are as Brandt would have printed them, but simply to bring
an important dimension of his work to light.

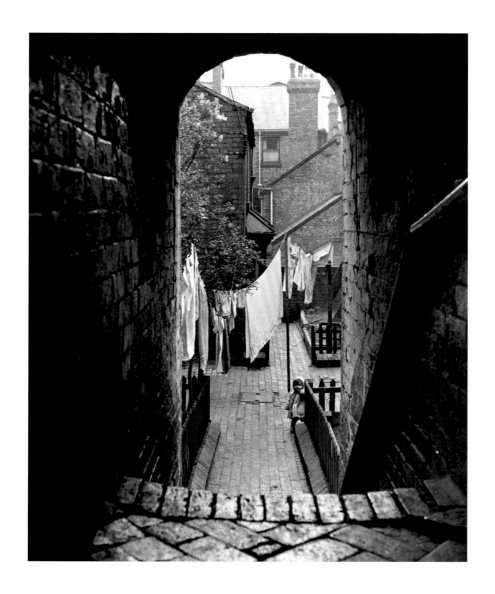

B.S.9

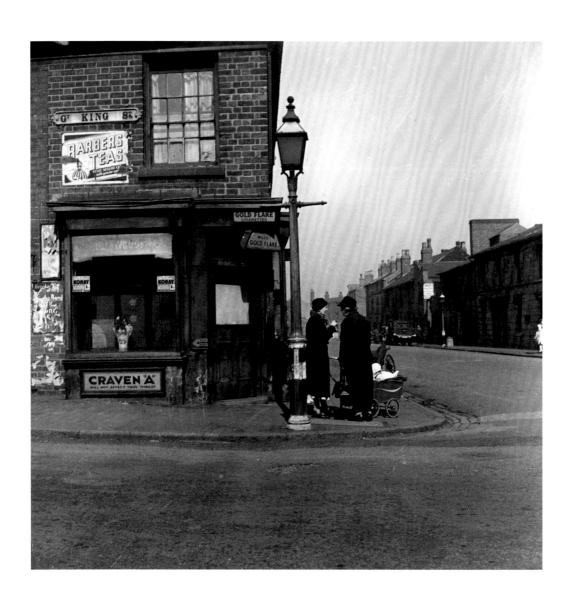

B.S.6

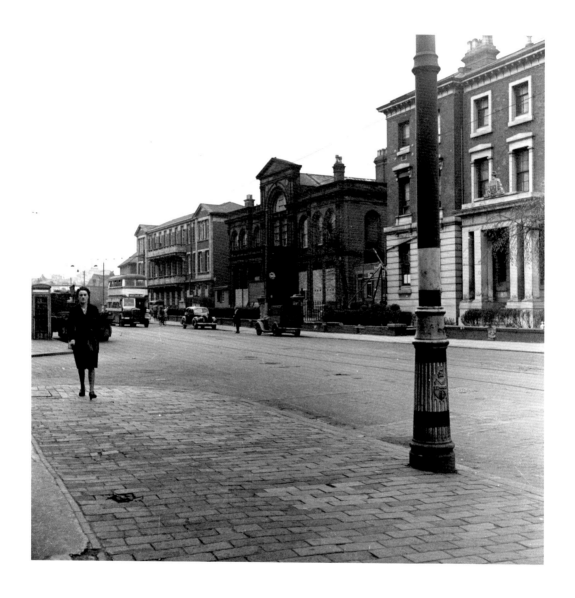

B.S.13

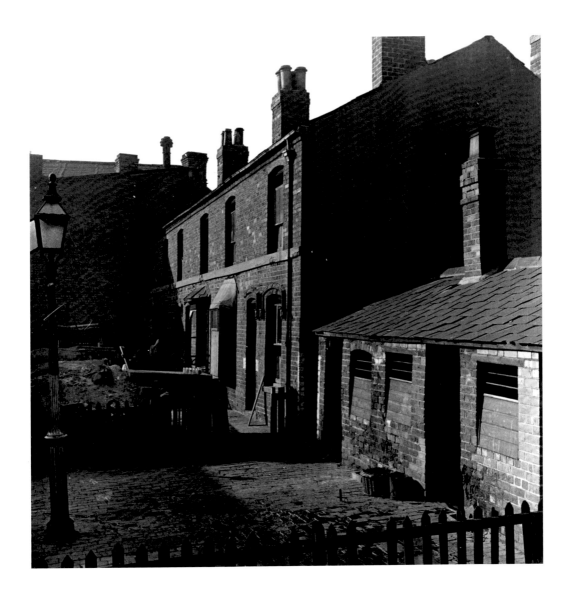

3.F.S.3

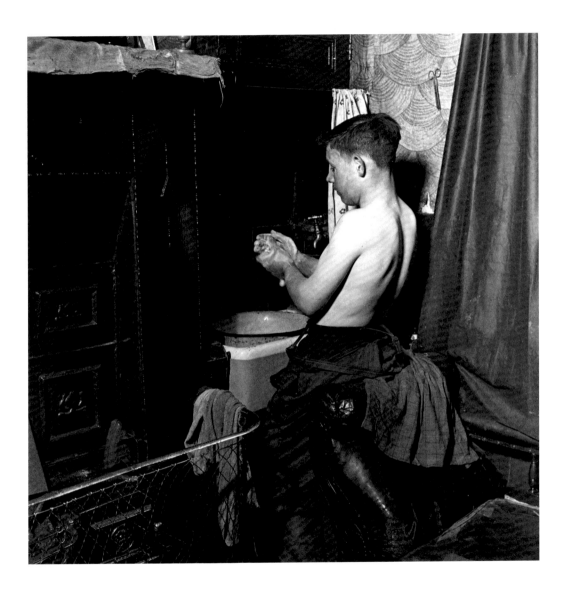

3.F.S.8

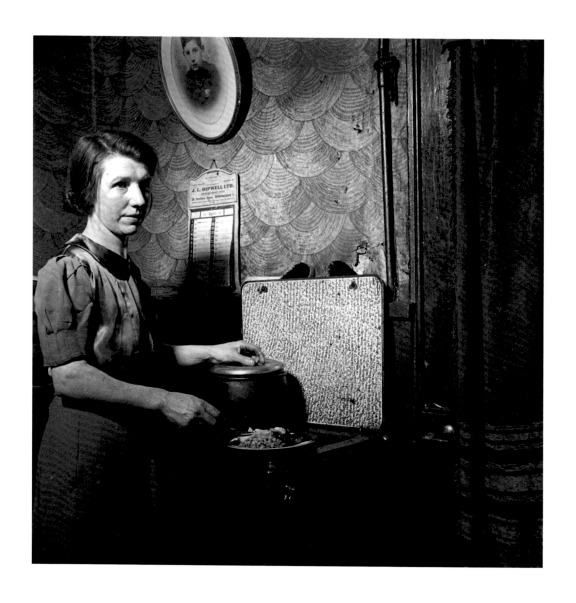

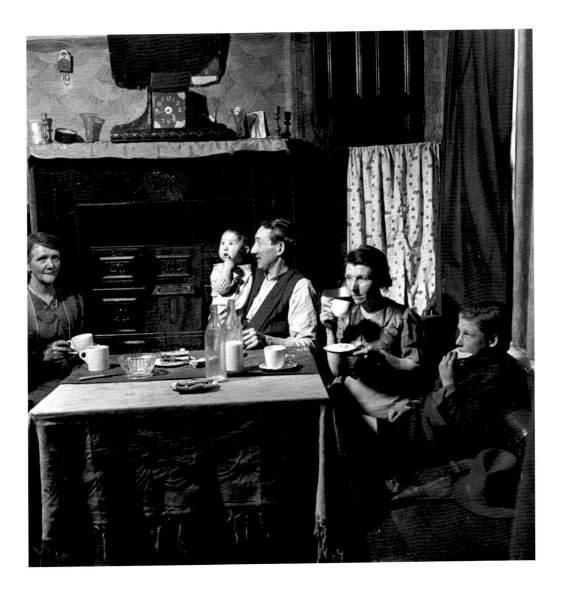

3.F.S.6

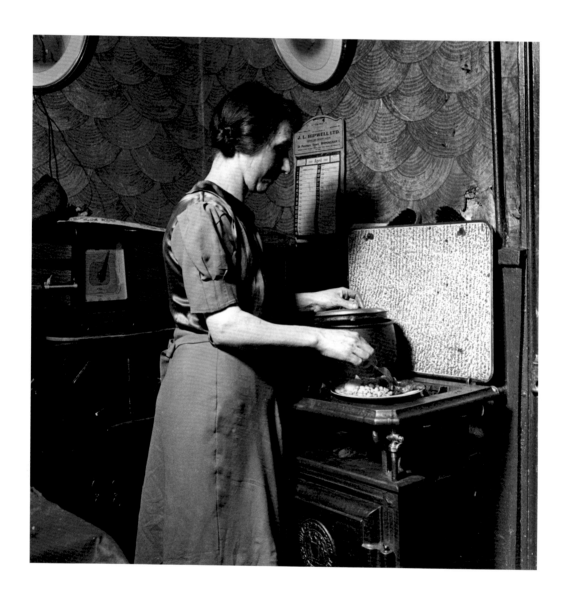

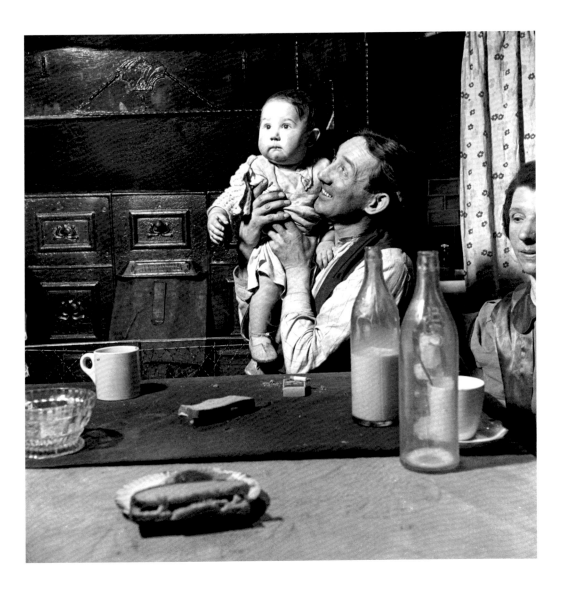

3.F.S.7

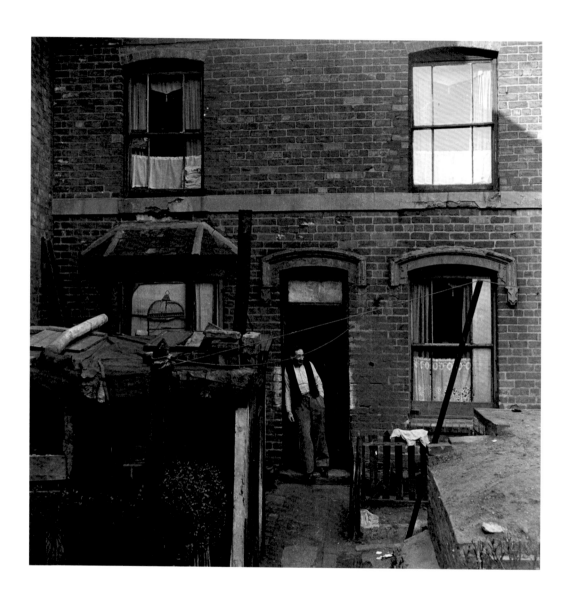

3.F.S.2

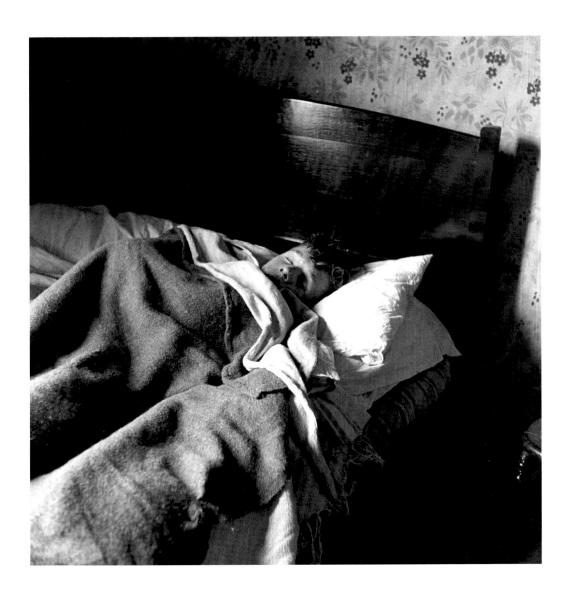

3.F.S.9

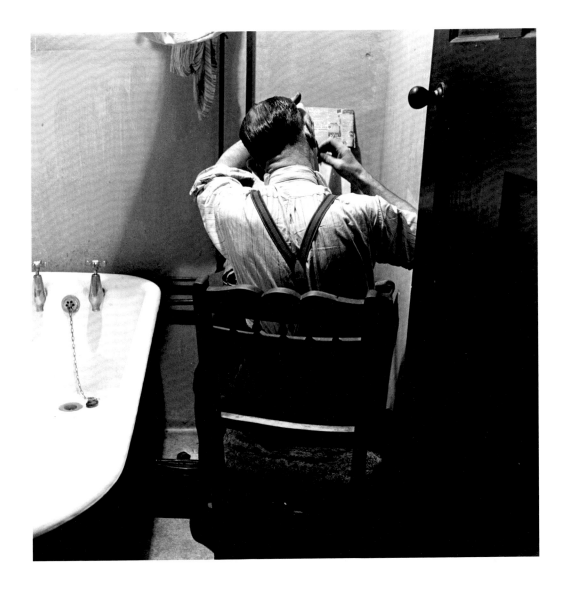

3.F.B.6

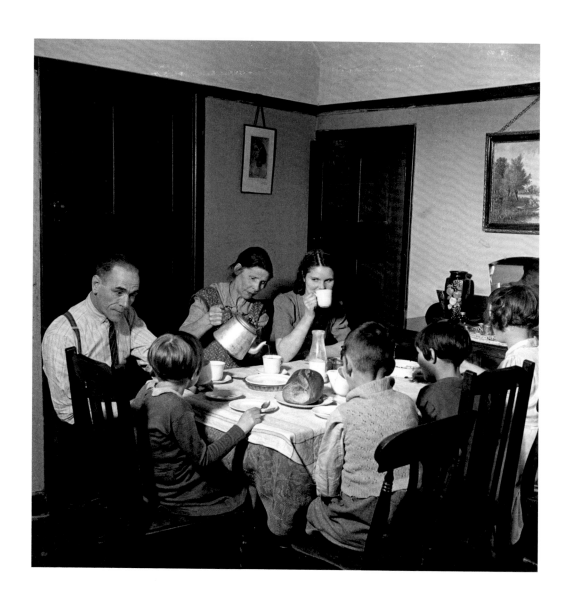

3.B.F.16

3.F.B.1

3.F.B.7

3.F.B.9

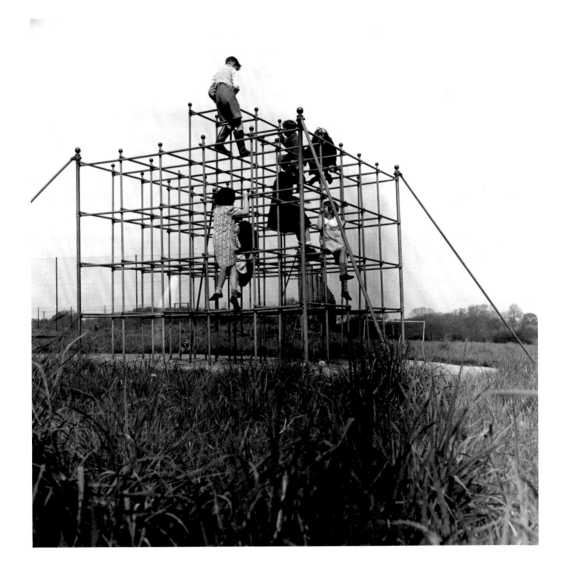

3.F.B.10

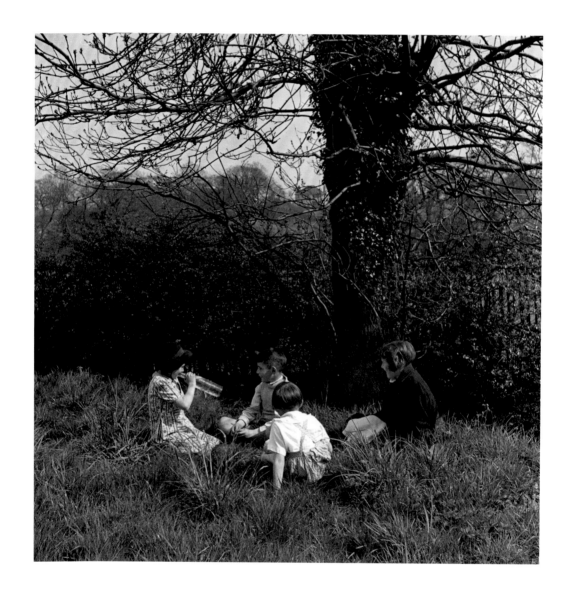

3.FB.13

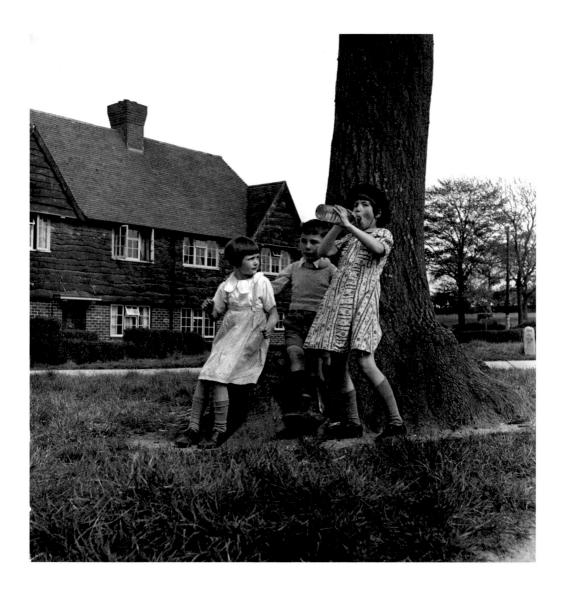

3.F.B.14

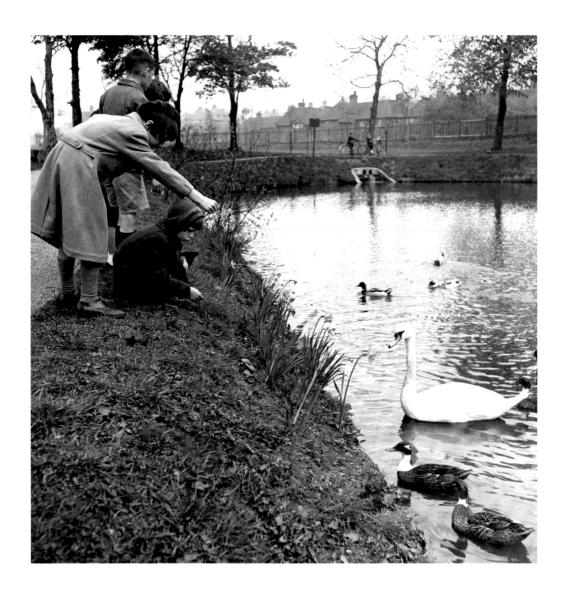

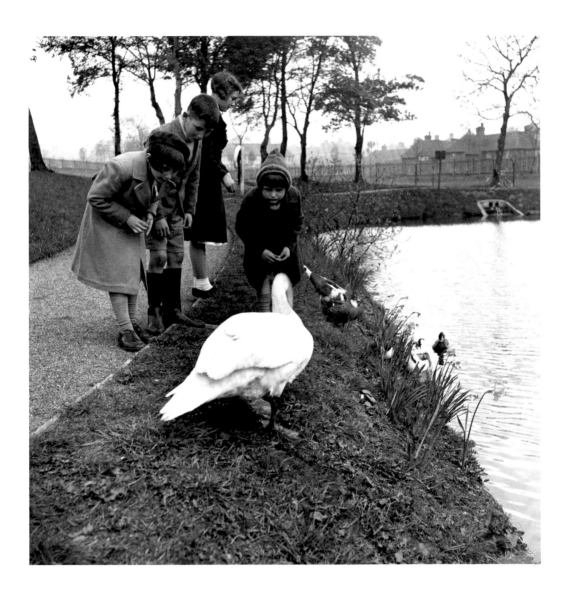

3.F.B.2

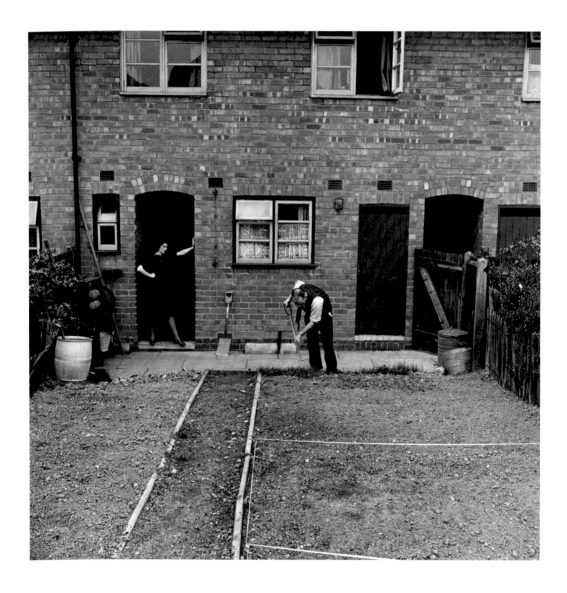

3.F.B.15

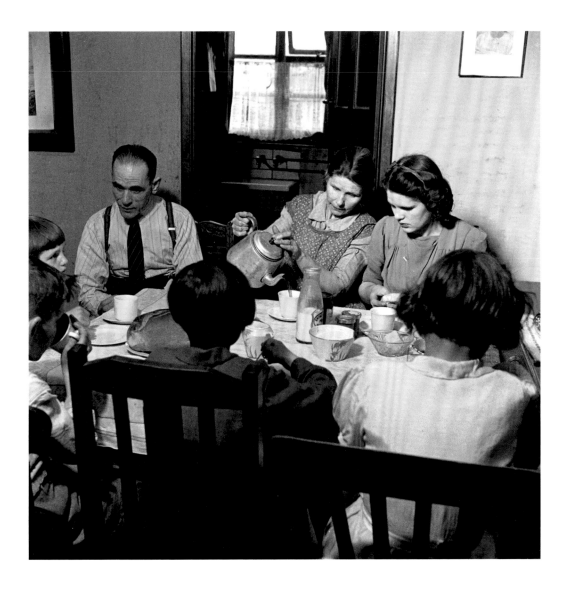

3.F.B.11

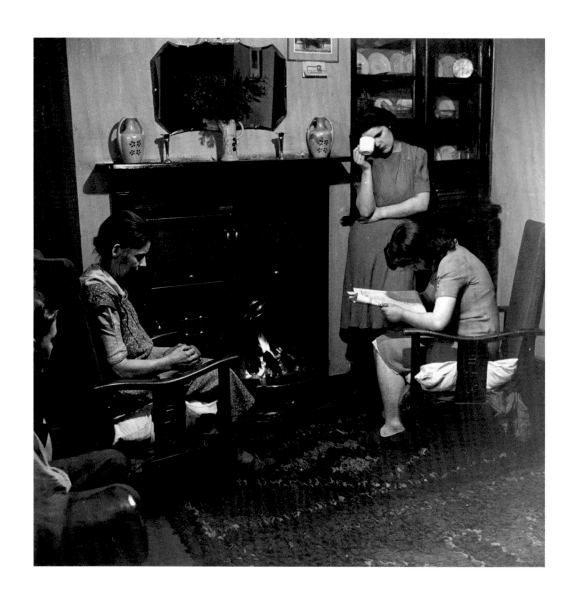

3.F.B.5

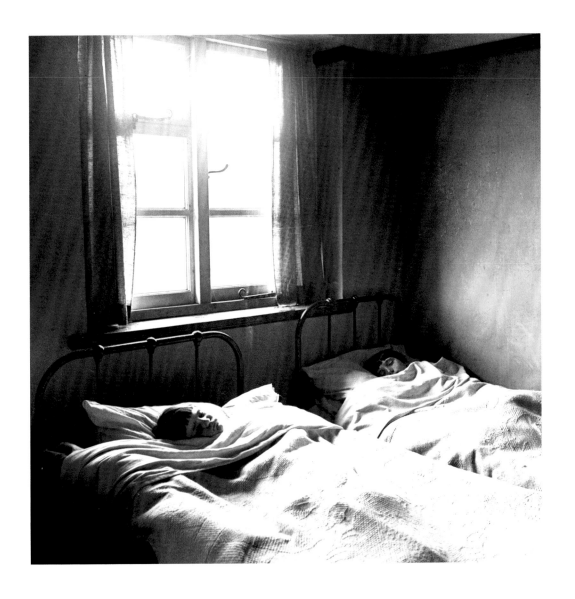

3.F.B.17

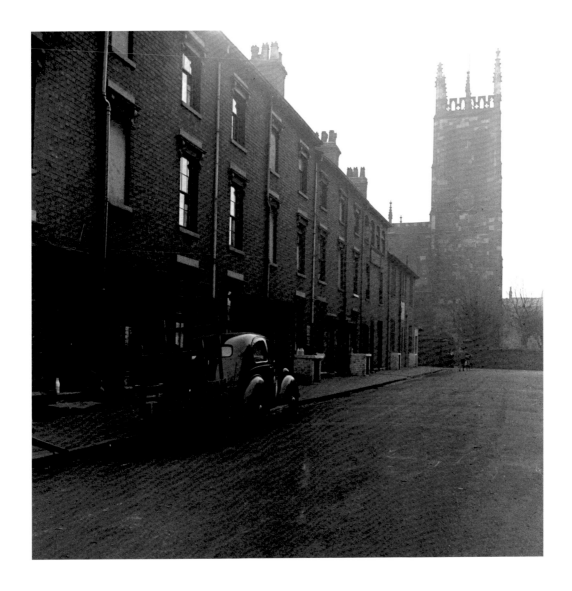

3.F.B.12

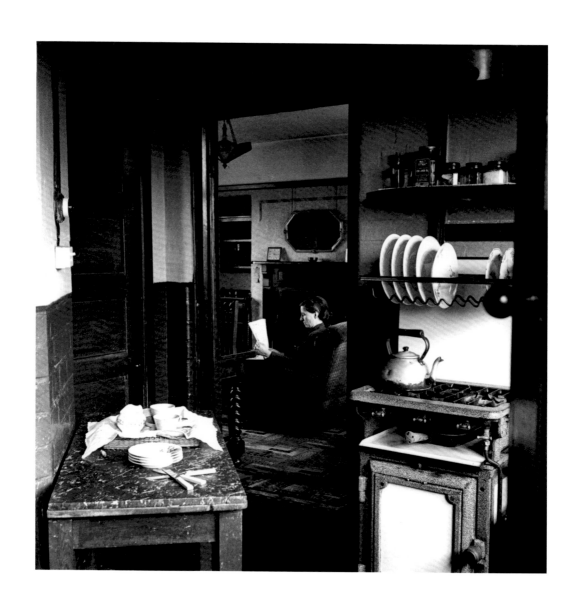

Y.3

Y.I

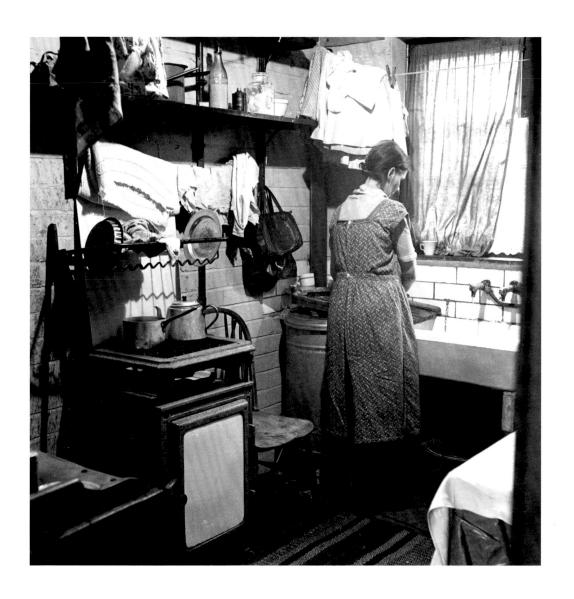

3.F.B.3

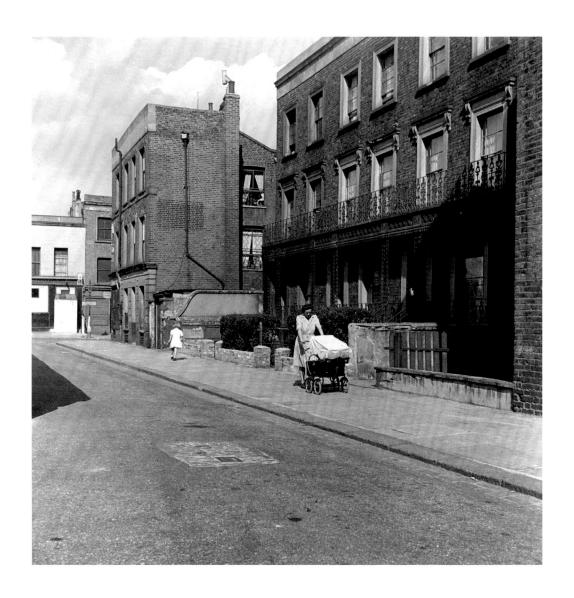

3.F.L.S.14

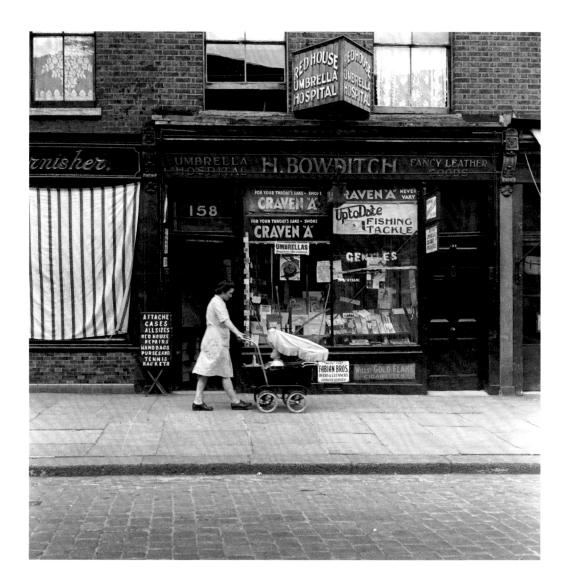

3.F.L.S.15

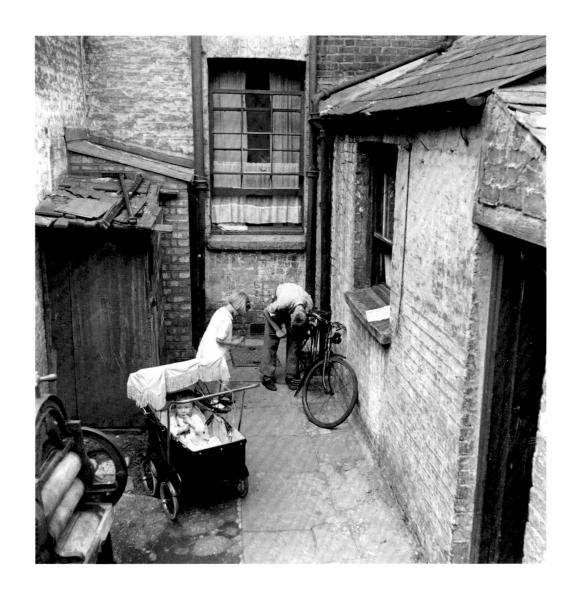

3.F.L.S.11

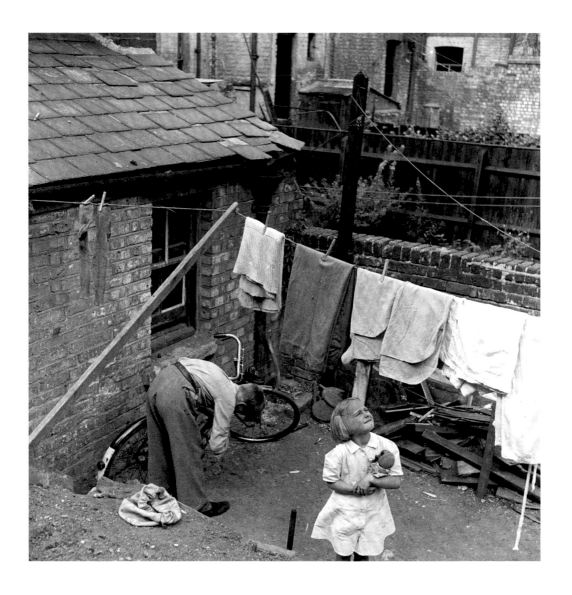

3.F.L.S.12

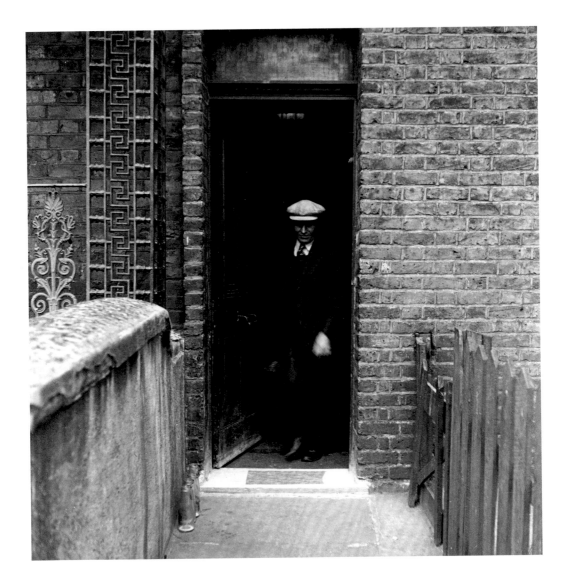

3.F.L.S.3

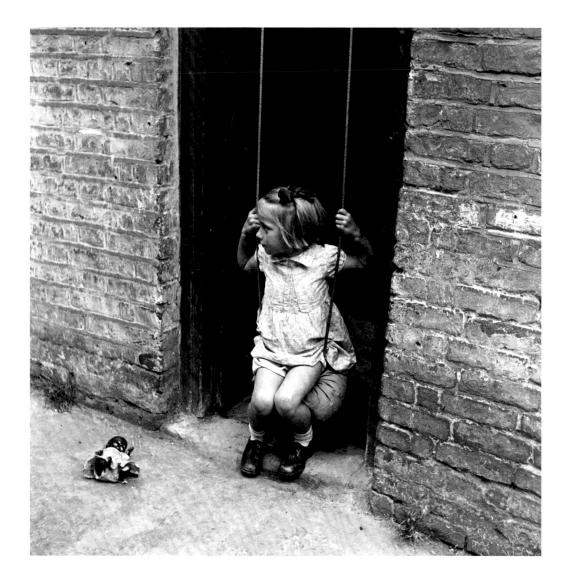

3.F.L.S.4

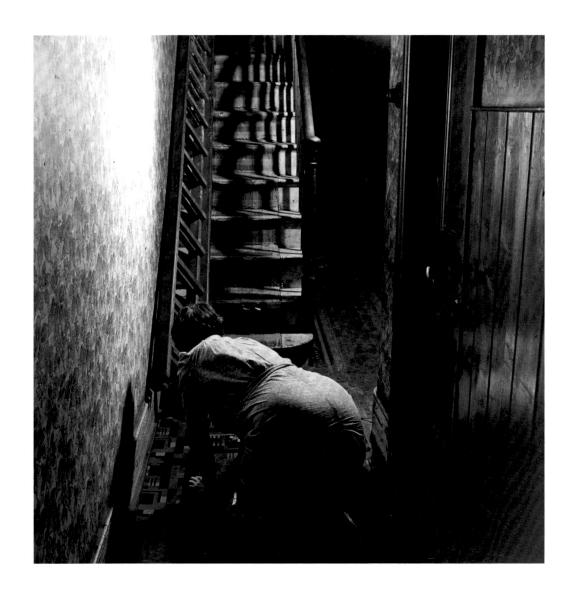

3.F.L.S.9

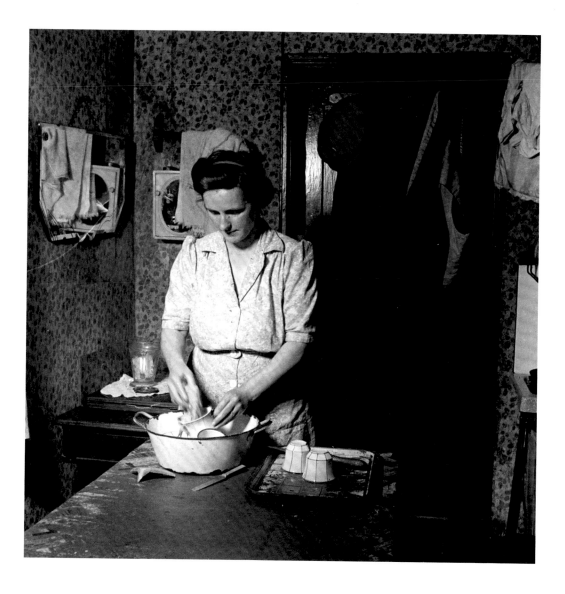

3.F.L.S.10

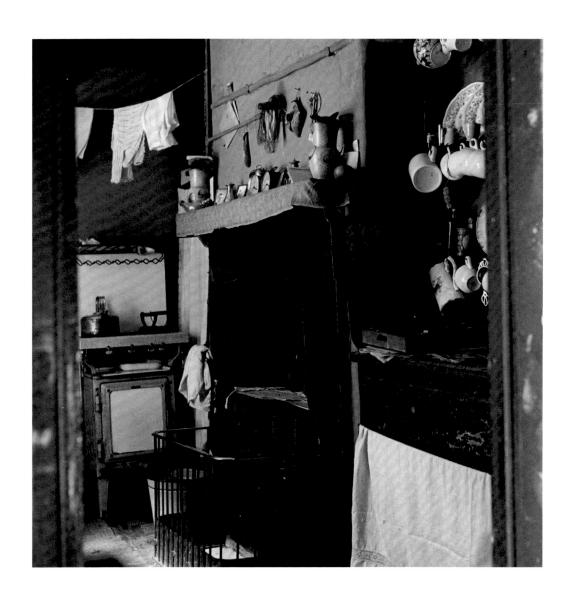

3.F.L.S.13

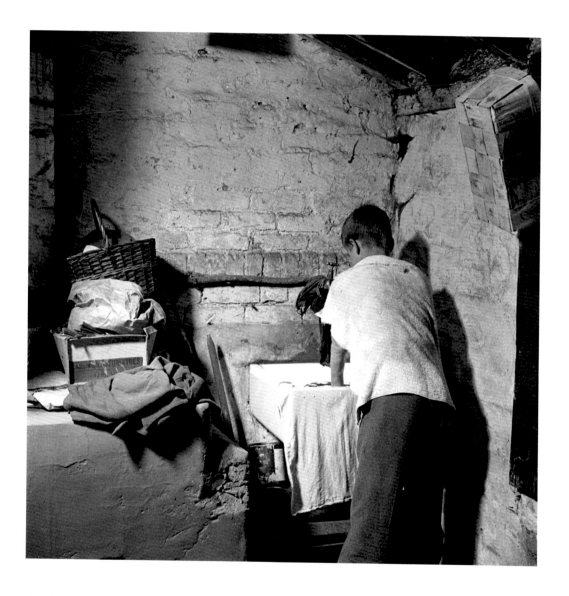

3.F.L.S.7

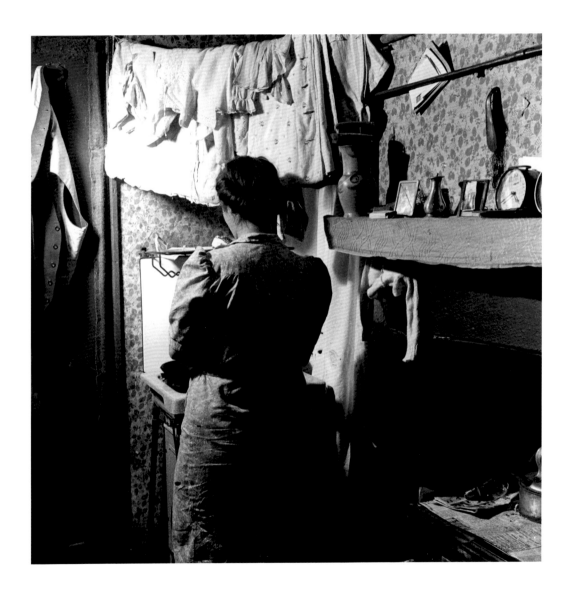

3.F.L.S.6

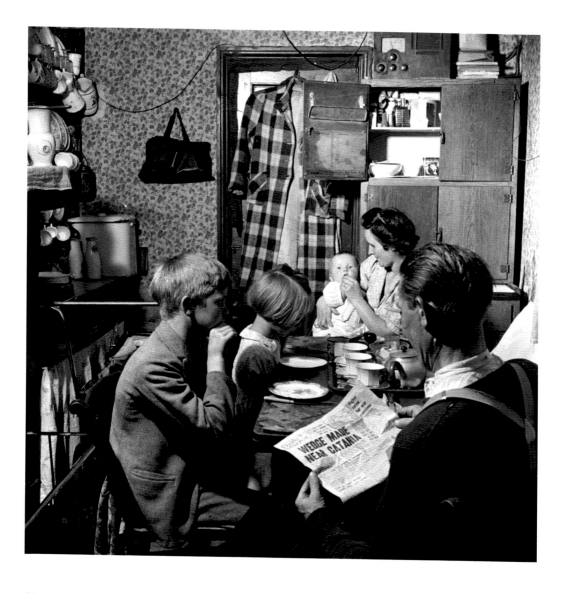

3.F.L.S.1

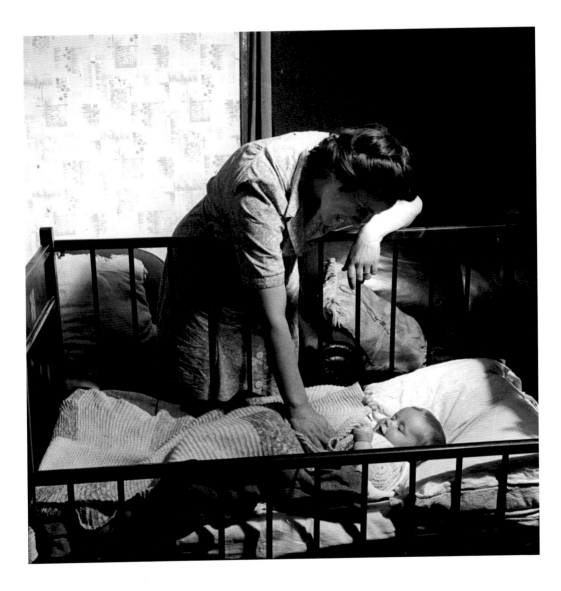

3.F.L.S.8

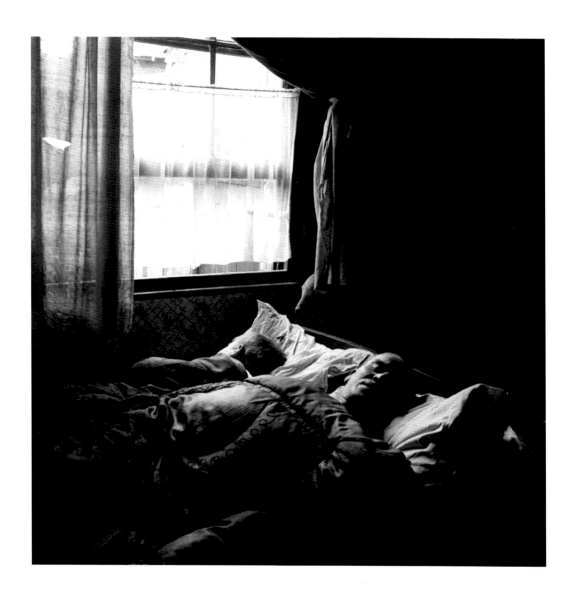

3.F.L.S.5

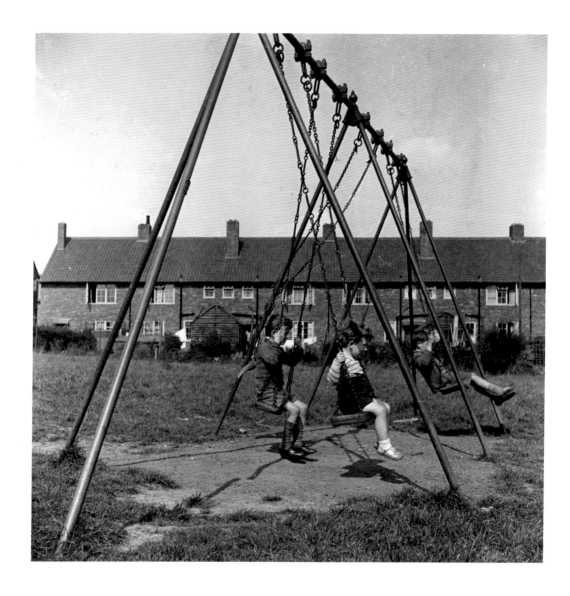

3.F.W.16

3.F.W.14

3.F.W.15

3.F.W.9

3.F.W.1

3.F.W.6

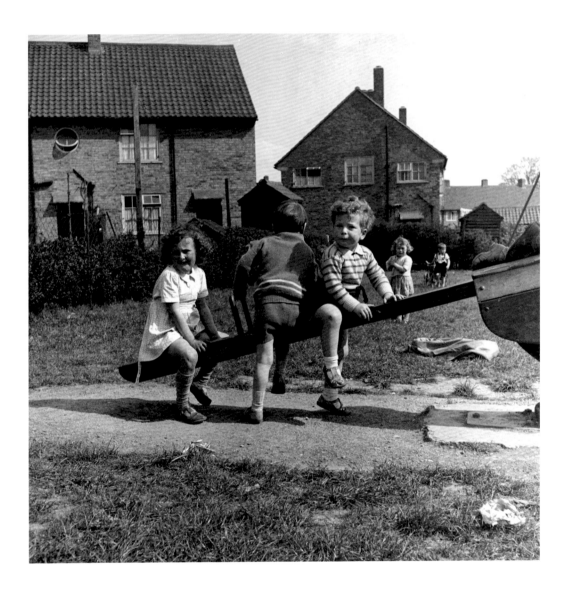

3.F.W.4

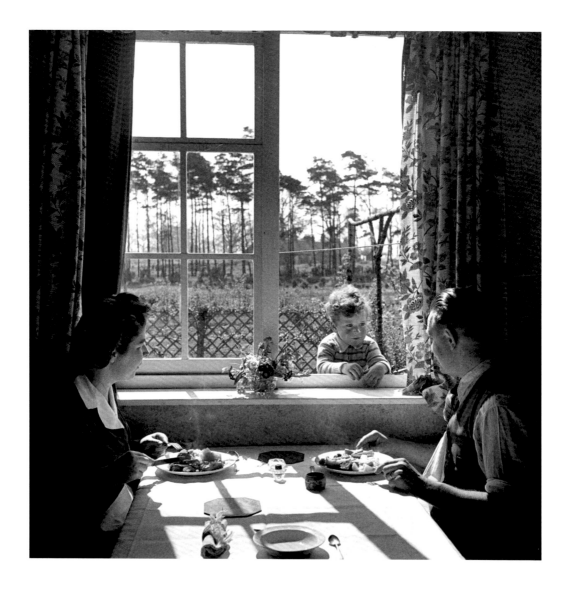

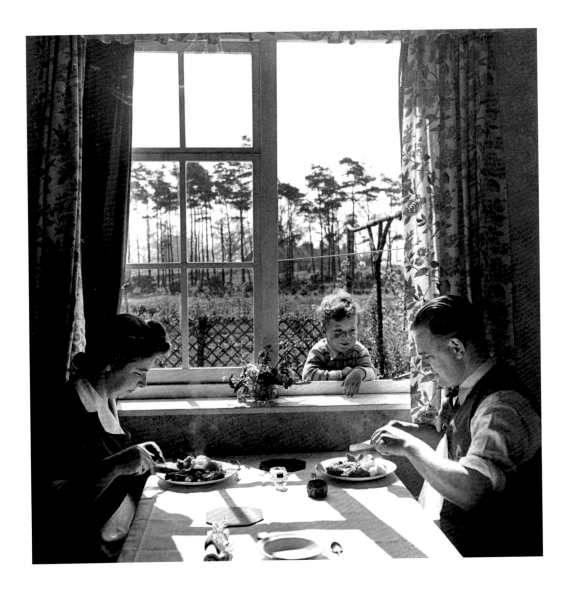

3.F.W.13

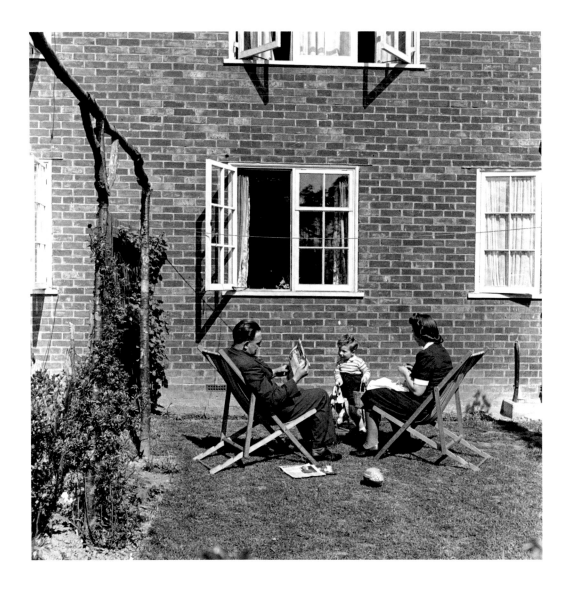

3.F.W.11

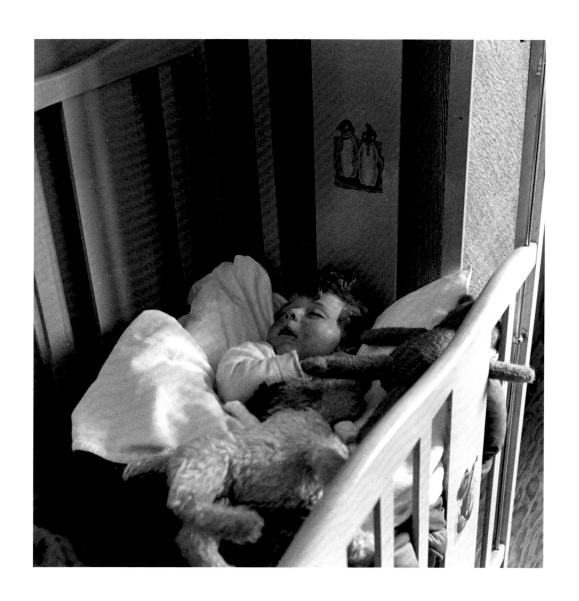

3.F.W.2

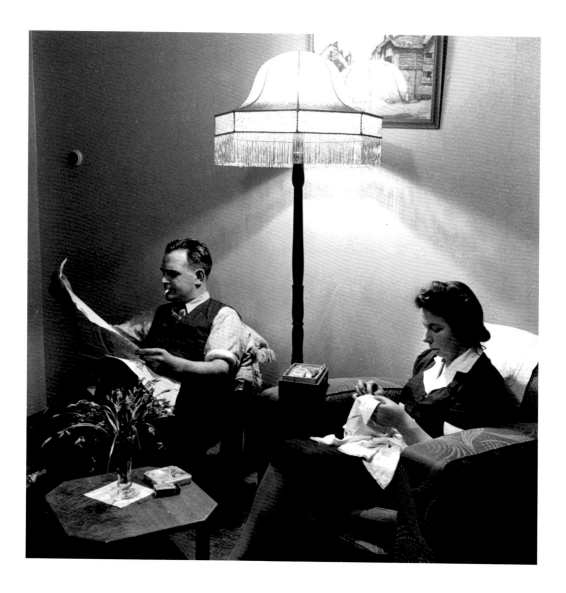

3.F.W.10

BILL BRANDT ON ASSIGNMENT

The Photographer's tale

The key to Brandt's approach with the camera is unveiled in his book *Camera in London* (1948) where he explains that to be of any substance such imagery has to be drawn from inside of you, from your own experience of moments of sadness, desperation as well as elation. Brandt expanded his thoughts on these subjects during our conversations in the mid 1970s. I began to understand much more about what he said and wrote when, in 1994, I started making a series of prints from his negatives for the exhibition at Birmingham Central Library. Commissioned work with defined parameters can only be effective if it is true to the photographer and his experience of that moment. And for me this is the stuff of art and contemporary photography irrespective of the method of production and practice.

What was Brandt's philosophy and how did he pursue this through his work? Brandt was loath to commit himself to a formula saying that 'a dangerous facility with words can cover up a problem by over-simplifying it' – a situation with which many photographers would sympathise. It appears that irrespective of the subject matter that Brandt had seen or sensed – he did not always know which – 'an atmosphere' that was inherent to his subject. He then tried to convey that atmosphere by intensifying the elements that composed it. He records 'I lay emphasis on one aspect of my subject and I find I can thus more effectively arrest the spectator's attention and induce in him an emotional response'.

Brandt was very conscious of the atmosphere created within an environment. He appeared particularly sensitive when entering a room for the first time. It was an experience he believed we have all shared at one time or another and he used this to describe the notion of what he defined as 'atmosphere'. In recalling this he says we can all come to a heightened awareness to a subject and lay ourselves open to a similar feeling. For Brandt, this is a feeling that can be both disturbing and reassuring.

Composition is important to Brandt but not something that he believed can be learned. As it was a vital factor in his work he worried that it could become an obsession or a formula and so destroy, not only the elusive 'atmosphere', but also the 'sense of wonder' that he felt and believed was essential when engaged in photographic practices. In achieving the latter he believed that another element was that of an unprejudiced eye. Such instinctive working methodology also drew heavily on past associations and influences either consciously or subconsciously.

Brandt always did his own printing. He varied his methods to suit his images and to overcome problems inherent in the sensitive materials available at that time. Management of, and the ability to deal with contrasty subjects was an "art" in itself. Photographic papers were not those with variable contrast that photographers today enjoy; contrast grades were limited and the "normal" grade made by one manufacturer was different in its tonal range from that of another. Of cameras he stated in *Camera in London* that "a perfect all round camera has yet to be made". He used the Rolleiflex Automatic favoured by many other professionals at that time. He also gives the technical data in that book for all the images reproduced. From this one can see that he liked to use roll film, with its advantage over 35mm film, of a larger image size and the resulting need for less enlargement to produce an image on 10" x 8" paper, the size demanded by most publications at that time. The Rolleiflex and the other cameras he used employed a 'reflex' method of viewing the subject at the full size and format of his negative, thus aiding composition. Brandt experimented with cameras which could give him different angles of view of the subject, but again like all the professionals of the day he was unimpressed because of their unreliability at that format size and the poor definition of the 'wide angle and telephoto lenses' available for them. The Rolleiflex, with its precision construction, shutter, optics and its slightly wide-angle lens became his favoured

instrument until the 1960s. However, from the 1930s until the 1950s the Rollieflex was not synchronised for flash bulbs. He therefore purchased a hand-held Sashalite Pistol Grip Reflector that enabled him to both direct the light from such a bulb as well as fire it. For Brandt the qualities and direction of light were key elements he used to induce in the viewer an emotional response – that elusive sensation of "atmosphere" which he felt when entering a room and the sense of wonder he believed was essential to making a good picture. These were the tools and methods Brandt used in making the images in the Bournville album, which, coupled with an instinctive working methodology, was at the heart of his approach to delivering this assignment, and exploring the personal picture making opportunities it provided.

Looking specifically at the Birmingham photographs in detail explains more of Brandt's working practice. In a view of the London kitchen (3.F.L.S.13) we note the way the room is lit. Comparing this with the photograph of a woman in this kitchen in front of the gas-stove (3.F.L.S.6) we see that this is different from that of the previous image. It is obvious that a light has been directed towards the cooker. Also there is an increased amount of laundry drying above the cooker and there has been a rearrangement of the objects on the mantelpiece and the range in the time that has elapsed between the two photographs as indicated by the clock.

A further look into image 3.F.L.S.6 shows the range that in the previous image (3.F.L.S13) was covered by a newspaper, now has an additional piece of newspaper on which lies an ES fitting light bulb. Domestic light bulbs of the time were bayonet fitting only and from earlier comment we know that Brandt used a Kodaflex lighting unit using ES bulbs. Brandt has previously remarked that attached to this unit was 'enough flex to stretch the full length of Winchester Cathedral'. In viewing the photograph of the ideal kitchen (3.F.W.1) and another of a couple reading at leisure (3.F.W10) we become aware that both images have been lit to help enhance the detail in the shadows, which

would have been difficult to adequately record without additional lighting, due to the inherent contrast range of films available at the time.

In another photograph of a family sitting at a table (3.F.S.6) we see again how Brandt has lit this situation with a lamp to the left-hand-side of the picture, in order to illuminate the child held by a male member of the family. When compared to the close-up of child and man (3.F.S.7) we realise objects on the table have been rearranged. This demonstrates another device that Brandt used to define the concept behind the assignment or his notion of 'atmosphere'. He is reputed to have stated that he did not use conventional or comp-ositional methods in arranging or framing his subjects. In fact he abhorred them.

The rearrangement of objects on the table is a compositional device that, coupled with the lighting, does induce in the viewer that emotional response to the selected subject. The image (3.F.S.7) encapsulates the 'atmosphere' of the situation in that room – of which Brandt was fully aware and which he wishes us to examine and share in the light of our personal experiences.

A further example arises in comparing images 3.F.W.11 and 3.F.W12. In image 3.F.W.11 a family is enjoying their garden, the therapeutic fresh air, sunshine and relaxation essential to good health, key factors of which Brandt is aware. The window in the centre is open, as are the other windows of the house. Here the child is standing between the seated parents. Note the height of the child and the distance from the ground to the window ledge. Compare this with image 3.F.W.12 with the child outside leaning on the windowsill and looking into the room, and it is evident that the child has grown remarkably. All devices were legitimate to this consummate professional who had a sense of humour, albeit ironic and surreal.

What is apparent with this body of work is that Brandt constructed his images bearing in mind the nature of the assignment. There were key photographs (3.F.S.7 and 3.F.W.12) where Brandt is the artist, in that they address the personal aesthetic he called 'atmosphere'.

Richard Sadler

BIIL BRANDT TOOK MY PICTURE

Shortly after the exhibition of Brandt's photographs opened in Birmingham in 1995, members of two families came forward having identified themselves in Brandt's photographs.

The first were members of the Dawson family, who, in 1938, moved from a back-to-back house in No.2 St George's Terrace, Brearley Street, Hockley (3.F.B.12) to a maisonette in Harborne and then to one of the modern municipal houses, No.116 Shenely Fields Road (3.F.B.1), on the Weoley Castle Estate. The Dawsons were one of the largest families in the area (eight girls and two boys) and their story epitomised the narrative of improved living conditions enjoyed by families who relocated from the city-centre to one of the new housing estates. Indeed the family was so large that even in their new house it was necessary for them to take turns to sit down at the table to eat. The family was also possibly chosen because their father symbolised the issue of Homes For Heroes – having fought in the First World War, then for six months in the Second World War, before being discharged when it was discovered that he had only one eye, having lost the other in WWI.

Jack Dawson recalled that in their original house "there wasn't any electric, there was no bath or nothing, we used to have a bath in the tub and we had a factory next door, a plating company and the wall, well it was bugs and fleas used to come through the wall from the factory next door". Whereas their new home "was a lovely place to live…just across the road all what we could see was fields". The children, all now in their sixties and seventies, recalled that Brandt arrived by car and photographed the family in the house. He then took them to a nearby park where he photographed them on a swing, the climbing frame (3.F.B.10), feeding ducks (3.F.B.14, 3.F.B.2), before returning to photograph their mother walking down Gregory Road (3.F.B.9). He finally took pictures of their father digging the garden (3.F.B.15). This caused some amusement because as Jack recalled "I always dig the garden and on the day the photographs were being taken in the back garden, my Mother said to me Dad, go and have your photograph taken digging the garden, but before that he never knew where the garden was, he wasn't interested cos he'd never seen a garden before."

Jack's sister, Mary, recollected that Brandt "came in a car and he gave us (my brother Dennis, Elizabeth my sister and myself) a bottle of lemonade… I'm photographed drinking the lemonade (3.F.B.14)… by what we used to call the big tree by the Sunshine House, Mr Phillips lived there at the time." From there "he took us down to the duck pond…he gave us the bread to feed the ducks, and I remember him being a very nice gentleman". "When we went down to the duck pond, he didn't sort of put us anywhere we were just walking around just feeding the ducks when he was taking the photographs, so I don't remember him – us posing and him saying like all be together now for this photograph, I think he just took them casually as we were looking at different things. But I do remember he was a very nice gentleman." When asked about how it was that her family came to be photographed, Mary recalled "I think it was something to do with my father working at Cadbury's and if my memory serves me right I remember my mother saying that Mr Brandt was going to send some photographs to Australia because we were a big family and some of the photographs were going to Australia, I do remember that quite vividly." – *Extract from an interview broadcast in the BBC film Bill Brandt – Traveller in a Strange Country, 2002.*

The second family that came forward was the Timothy family. Chris Timothy, himself a professional town planner, explained that the photographs of the family in the Birmingham slums (3.F.S.1-9) were of his mother, Margaret Timothy's in-laws and that the photographs were taken before she met his father. The boy at the Belfast sink, James Thomas Timothy (3.F.S.8) is thus Margaret's husband-to-be and Chris Timothy's father. Magaret Timothy recollected that the house was in Watery Lane, Small Heath/Bordesley Green. When she met her husband-to-be the Timothys lived at 105 Coventry Road on the corner of Bordesley Green Road. She recalled him referring to his family, including her

Members of the Dawson family, originally photographed by Bill Brandt when they were children. (Photograph by Richard Sadler).

sister, Eveline and brother John also living in or around Watery Lane. The Timothys lived at 105 Coventry Road until 1970. The house now lies under the MacDonalds just below the Blues Ground. Chris Timothy's recollection was that it was not much better than the house in the photographs. It was around a courtyard where there was a chicken run.

James Thomas Timothy worked for Bryant's before joining the Royal Navy. Chris Timothy assumes that he was working for Bryant's when the photograph was taken. His father would have been 15 in 1943. He was then in the Navy until 1954, having spent 12 months in Australia as part of the atom bomb tests. The woman at the stove (3.F.S.4 & 5) is Chris Timothy's grandmother, "Nanny Tim" – Florence Timothy. Up to her death in 1968 she worked in a local factory. In the same picture, hanging on the wall above her, is a framed photograph of Chris Timothy's Uncle Bill, his Dad's oldest brother, who ended up as a Captain with the Ghurkhas.

In photograph 3.F.S.6, besides Florence Timothy, is Chris Timothy's Grandfather, Thomas Henry Timothy. Chris's research revealed that "the baby in his arms is my Aunty Sylvia, and the boy eating the jam butty is my Uncle Harold, my Dad's youngest brother. Mom knows that he was 11 years older than Sylvia. The sailor in the photograph would be my Uncle Johnny, the second eldest brother. Mom assumes that the old lady on the left hand side is Nanny Hollier, Florence's Mother."

He went on to explain that Thomas Henry Timothy served in WWI. "He was sent home

having been gassed, something my Mom tells me he never stopped talking about. My Mom tells me that he worked as a grave digger, rat catcher and as a cobbler. I recall him having a cobbler's workshop at 105 Coventry Road. Granddad Tim died in 1970 aged 70."

Chris Timothy said "I find it ironic that despite having been gassed, none of his sons or daughters lived to such a ripe age. All are now dead. I find the photographs fascinating. They take pride of place in our house and never fail to generate interest from visitors. The photograph of my Dad was a bonus as there are precious few of him and only one when he was a schoolboy!

"The fact that my family was part of a project intended to improve housing conditions is not lost on me as a town planner. I reckon that most planners choose the profession because they care for and want to improve the environment, especially the built environment. These photographs certainly explain graphically why you need town planning. The "Home fit for Heroes" objective after WWI clearly failed, as my Granddad was sent home, and his house didn't seem to befit a hero.

"Housing conditions for all the population are now certainly better. Thanks in no small part no doubt to the planning system. We cannot rest on our laurels. These houses were replaced by Castle Vale, Chelmesley Wood etc. These areas have and continue to need to be improved; farewell the tower blocks at Castle Vale for example.

"Every time I look at the photographs it makes me grateful for the conditions I live in and that I had the ability and opportunity not to have to endure such poor conditions. It also reminds me that in such a relatively short time the Timothys (my brother, sister and I) have come a long way since the conditions my Dad experienced. It is such a pity he was not alive for long enough to have seen it for himself."

The Bournville Village Trust Album

This list follows the original page sequence of the file prints in the BVT album.

3.F.W.1-13: Municipal Estate, Kingstanding, Birmingham, 1939.
The Kingstanding Estate lies five miles to the north of Birmingham. Its modern houses were sited along broad, grass-verged roads and were supplied with hot and cold running water, modern cooking facilities, bathrooms, a well-lit parlour and living rooms fitted with cupboards. Ample gardens and nearby recreation facilities offered play areas for children, as did the countryside beyond.

3.F.B.1-16: Back-to-Back Slum House, St. George's Terrace, Brearly Street, Hockley, Birmingham, and Shenely Fields Estate, Weoley Castle, Birmingham, 1939.
In 1941 there were over 38,000 back-to-back houses in Birmingham, housing between 100,000 and 150,000 people. Most of these properties were built in the early nineteenth century by speculative builders who crowded as many houses as possible onto the sites available. The modern "artisan's homes" on the Weoley Castle Estate were built between 1931 and 1934. The houses show superior planning and architectural treatment to those of the early speculative builders. They frequently contained rooms fitted with cupboards, fireplaces, electric lighting, hot water, gas heating, gardens and play areas for children nearby.

3.F.S.1-9: Back-to Back Slum House, near Watery Lane, Small Heath, Birmingham, April 1939.
Situated near the Birmingham City Football ground, these back-to-back usually contained three rooms; a kitchen-living room with a bedroom above, and over that an attic. The houses were built in a double row under a single roof, one row facing the street, the other facing a paved courtyard. Almost every house was therefore surrounded on three sides by similar dwellings preventing through ventilation or adequate daylight illumination. As early as 1840, a Select Committee had condemned back-to-backs as unsuitable for people to live in. The calendar in the photographs of the kitchen gives the date of these images as being April 1943.

B.S.13 & Y1-4: Bath Row (B.S.13), and unidentified municipal housing, possibly near Five Ways /Lee Bank, Birmingham, 1943.
Bath Row, located just outside the city centre, was the location of both Davenports Brewery and Birmingham Accident Hospital. It was an area scheduled for redevelopment by Birmingham's Reconstruction Committee in 1943. Blocks of flats replaced much of the housing that existed there previously. These have recently been the subject of a major renovation project run by the Optima Housing Association. Optima engaged the services of the Birmingham-based documentary photographer, Vanley Burke, to record the tenant's response to these improvements.

B.S.1-12: Back-to-back and Tunnel-Back Slum properties, Hockley, Birmingham, 1943.
These include views into the courtyards of back-to-back and tunnel-back houses in the inner-city, probably in Hockley. These paved courtyards served as a drying area for washing and as a playground for children. A few water closets for the common use of tenants were grouped in the courtyard alongside the "brewhouses", or wash houses, which tenants used one day a week for washing. Entrance to the houses in the courtyards was through a narrow passage tunnelled through the block of houses fronting on to the street which also served as a playground for children. The Street signs locate two of the images as being Great King Street and Great Hamilton Row, in Hockley. These streets were located close to factories such as that owned by Lucas, and the areas were therefore prime targets for German bombers during the war.

3.F.L.S1-15: Slum Housing, near the Malden Road, London, 1943.
These old residential properties were located near the Malden Road, London, NW5, not a great distance from Brandt's home in Campden Hill. The newspaper headline, 'Wedge Made near Catania' relates to a Second World War campaign in Italy fought around July 1943.

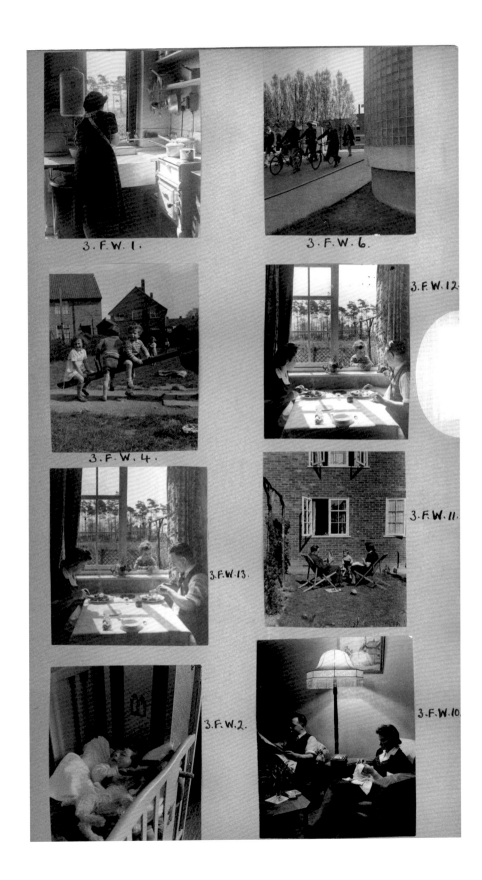

3.F.W.1.

3.F.W.6.

3.F.W.12.

3.F.W.4.

3.F.W.11.

3.F.W.13.

3.F.W.2.

3.F.W.10.

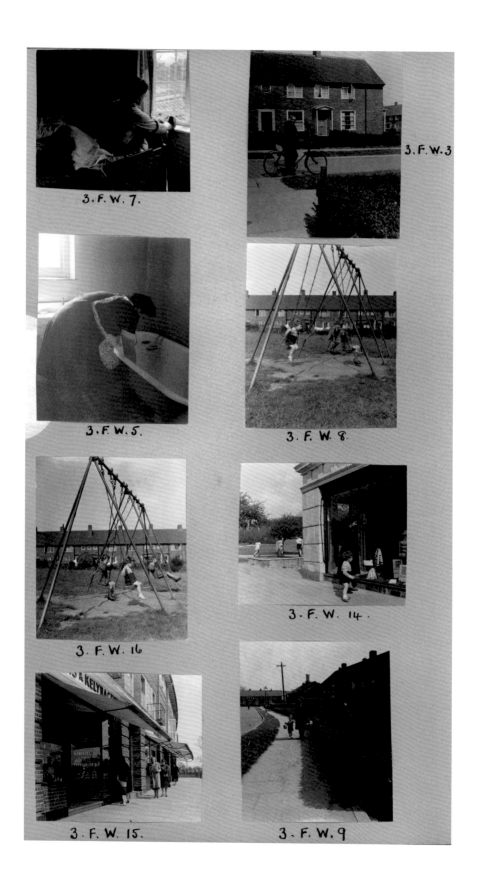

3. F. W. 7.

3. F. W. 3

3. F. W. 5.

3. F. W. 8.

3. F. W. 16

3. F. W. 14.

3. F. W. 15.

3. F. W. 9

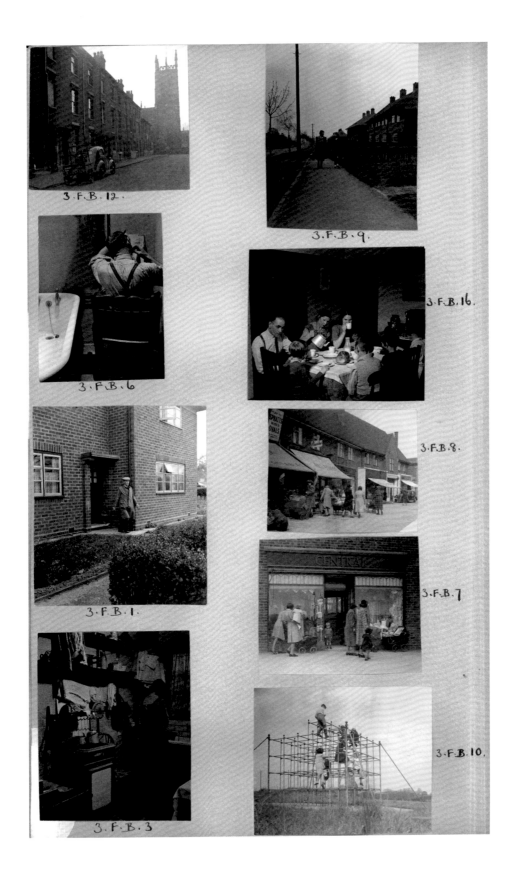

3.F.B.12.

3.F.B.9.

3.F.B.6

3.F.B.16.

3.F.B.8.

3.F.B.1.

3.F.B.7

3.F.B.3

3.F.B.10.

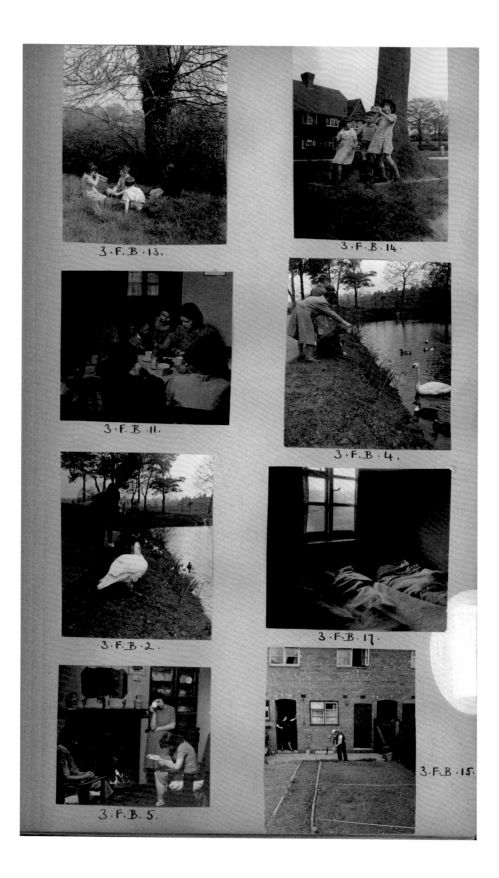

3 . F. B . 13 .

3 . F. B . 14 .

3 . F. B . 11 .

3 . F. B . 4 .

3 . F. B . 2 .

3 . F. B . 17 .

3 . F. B . 5 .

3 . F. B . 15 .

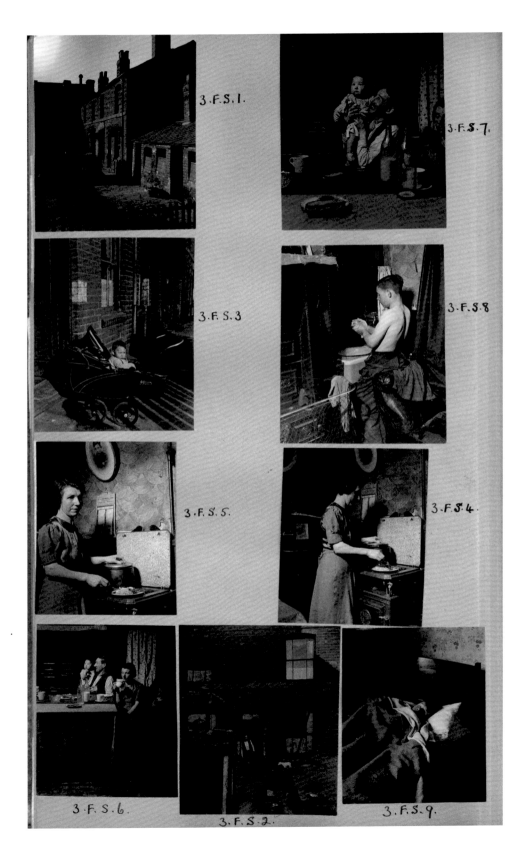

3.F.S.1.

3.F.S.7.

3.F.S.3

3.F.S.8

3.F.S.5.

3.F.S.4.

3.F.S.6.

3.F.S.2.

3.F.S.9.

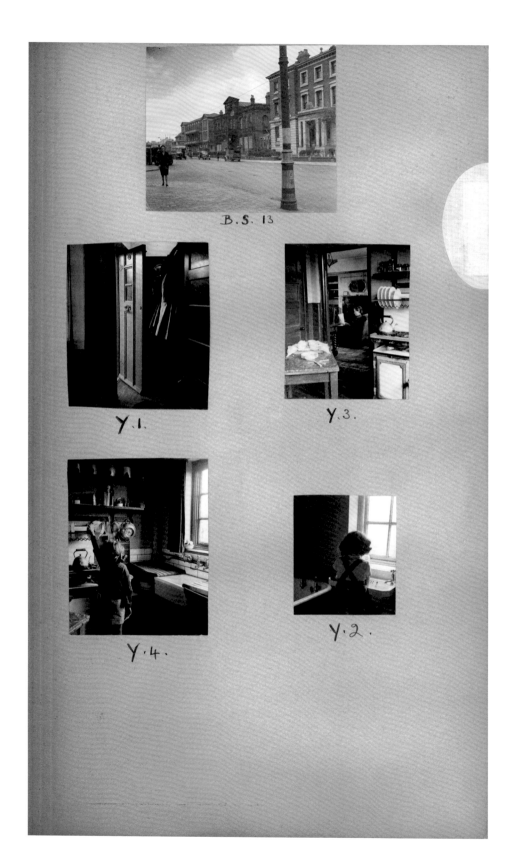

B.S. 13

Y.1.

Y.3.

Y.4.

Y.2.

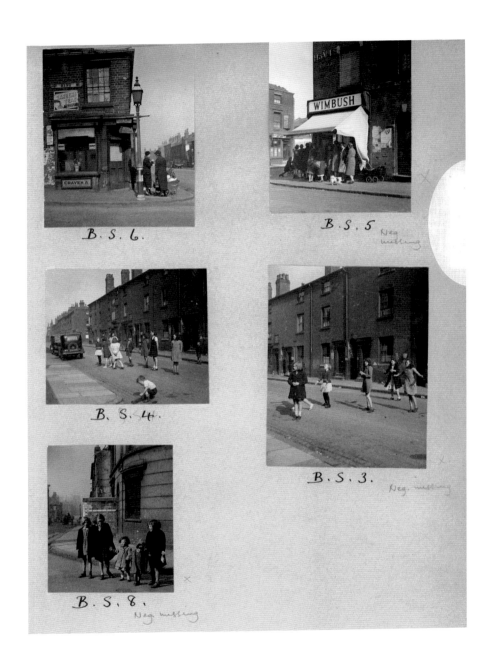

B.S.6.

B.S.5 Neg.
missing

B. S. 4.

B.S.3.
Neg. missing

B.S.8.
Neg. missing

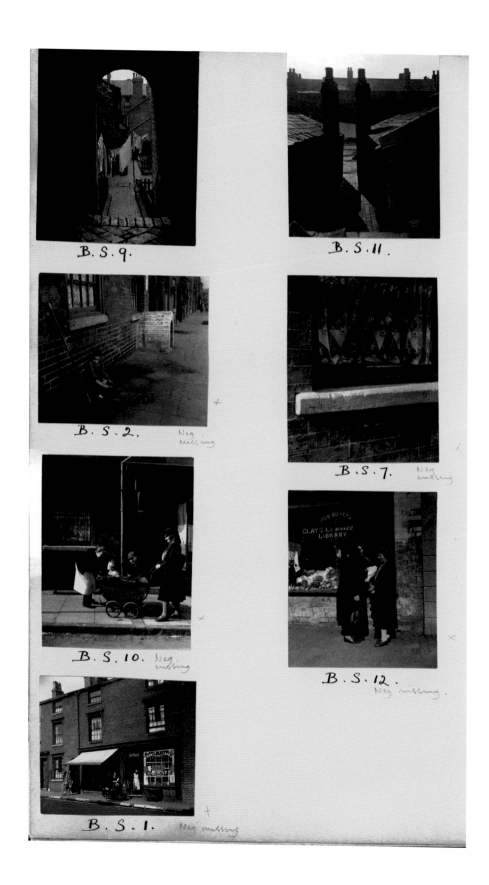

B.S. 9.

B.S. 11.

B.S. 2. Neg. Missing

B.S. 7. Neg missing

B.S. 10. Neg. missing

B.S. 12. Neg missing.

B.S. 1. Neg missing

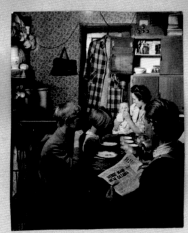

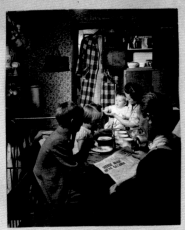

3.F.L. S.I

3.F.L. S.2.

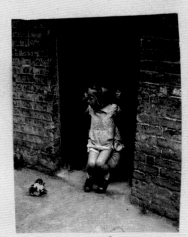

3.F.L. S.3

3.F.L. S.4.

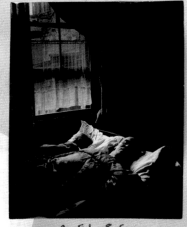

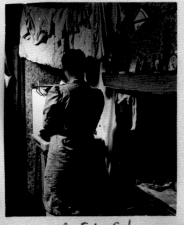

3.F.L. S.5.

3.F.L. S.6.

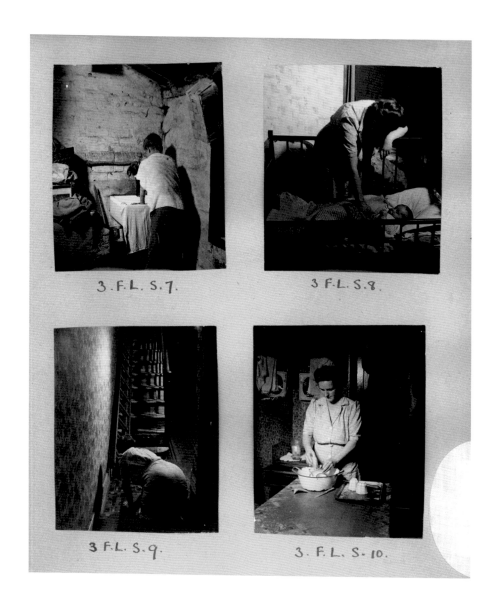

3.F.L.S.7.

3.F.L.S.8.

3.F.L.S.9.

3.F.L.S.10.

3. F. L. S. 11.

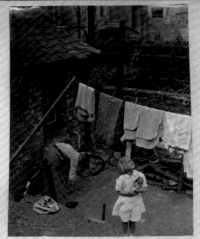

3 F. L. S. 12.

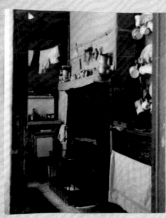

3. F. L. S. 13.

enlarge, not camera, shake?

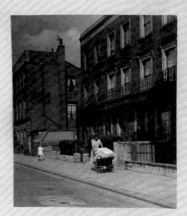

3. F. L. S. 14

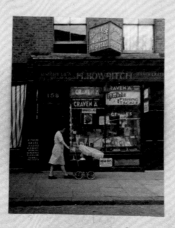

3 · F. L. S · 15.

HOMES FIT FOR HEROES

The work of Bill Brandt and other photographers played a key role in charting social history, documenting living conditions in a way that helped to support the quest for improved housing and post-war reconstruction.

The Bournville Village Trust (BVT) has played a critical role in this process in the West Midlands. They commissioned these photographs by Brandt, but also produced important reports such as *Birmingham Fifty Years on, When We Build Again* and *Conurbation: A Planning Survey of Birmingham and the Black Country*.

This latter report was published in 1948 and was produced by the 'West Midland Group on Post-War Reconstruction and Planning'. Dr. Raymond E. Priestley, Vice-Chancellor of the University of Birmingham, chaired it and Paul S. Cadbury was Honorary Secretary. BVT provided the staff to support the Group in its work and conducted a considerable amount of the research required. The book was published by the Architectural Press, London and included a foreword by Lewis Mumford, the famous American sociologist, who had visited Birmingham during the time the book was being prepared and met with members of the Group.

It was an important document, well illustrated with photographs, graphically displaying the urban condition of the conurbation. It included one particularly interesting set of images taken from a train window on the 14-mile journey from Birmingham to Wolverhampton. These illustrated the industrial and congested nature of the area and how factories were intermingled with housing in a rather haphazard fashion. It highlighted the derelict land that was left from the closure of previous industrial activity and the need for the regeneration of this ailing industrial landscape. The purpose of the report was to assemble facts and figures about the conurbation on which future decisions about reconstruction and development could be made. It was not seen as a plan, but rather as providing the evidence base for future action.

BVT have recently revisited this important document by commissioning CURS to undertake a contemporary review of the conurbation to provide a snapshot of the urban condition of the area today. It is hoped that like its predecessor it might again act as a platform to inform future policy. A collaborative venture between the University of Birmingham, Birmingham Central Library and Wolverhampton University, the project has received financial support from BVT and from a number of local authorities including Birmingham City Council, and the Metropolitan Borough Councils of Wolverhampton, Dudley, Solihull and Walsall. A key element is the sequence of photographs by Nick Hedges replicating the original train journey, fifty years on.

The work will shortly be published and will hopefully be seen as a useful companion to this collection. Both publications serve to highlight the importance of photography in helping us to enhance our knowledge and understanding of urban areas, and inform the constant need for ongoing reconstruction.

Dr Mike Beazley
Centre for Urban and Regional Studies
University of Birmingham

Footnotes

1). See Michael Hallett, 'The Lost Brandts', *British Journal of Photography*, 2 March 1994, p.12-13 and the list of other articles relating to their re-discovery in the Selected Bibliography at the back of this book.

2). *Rebuilding the Home Front, Photographs by Bill Brandt 1939-1943*, Birmingham Central Library, 14 December 1995 to 14 February 1996. The speakers giving lunch-time lectures included John Taylor, Paul Delany and Nigel Warburton. A review of the one day symposium held on 10 February 1996 by Dr Michael Harrison, University of Central England, can be found in *Planning History, Bulletin of the International Planning History Society*, vol.18 no.1, 1996, p.39-41.

3). Nigel Warburton, 'Brandt's Pictorialism', *Bill Brandt, Selected texts and bibliography*, Oxford, Clio Press, 1993, p.1.

4). This process was one of the factors that motivated this author to re-examine and in a number of instances correct some of the detail and conclusions presented in the original exhibition and associated articles published in 1994-95.

5). The Sir Benjamin Stone Collection is also held in Birmingham Central Library.

6). See Ian Jeffrey, 'Brandt's Reticence', *Bill Brandt, Photographs 1928-1983*, London Barbican Art Gallery in association with Thames and Hudson, 1993, p.12-14.

7). Describing a similarly little known body of Brandt material, Nigel Warburton ('Bill Brandt's Cathedral Interiors, Rochester and Canterbury, *History of Photography*, vol. 17 no.3, p.263), such images "have the value of a painter's sketchbooks" because "we can see Brandt trying out different ideas; see how, working within quite narrow constraints, he could still produce subtle and arresting pictures."

8). Mark Haworth-Booth, quoted in the British Journal of Photography ('Huge Brandt cache comes to light' 3 February 1994, p.4.) said "What I do find interesting about the photographs, however, is that Brandt's themes and obsessions can be found here even in a commercial assignment such as this."

9). Richard Sadler recalled that their meetings took place at the time that Brandt was preparing work for his exhibition at the Malborough Gallery and a new edition of his book *Perspective of Nudes 1945-1980*.

10). The album itself carries a lable inside the back cover that tells us it was made by Cond Brothers of Birmingham, Accountants Book Manufacturers. This label also bears the date "August 11 1930". It therefore appears that Muirhead re-used this accountancy file to store the Brandt prints.

Eight of the negatives are listed as 'missing'. There also seems to have been some confusion in identifying one negative as the file print of the view into a Birmingham slum courtyard (B.S.11) does not exactly correspond with the negative in the collection. A similar view, unquestionably from the same roll of film is reproduced in Bill Jay and Nigel Warburton, *The Photography of Bill Brandt*, Thames and Hudson, London, 1993, p.147.

11). Bournville Village Trust Archive, MS1536.

12). Letter from Ian Jeffrey to Peter James, 12-1-94.

13). Nigel Warburton ('Brandt's Printing Styles', *The Photography of Bill Brandt*, p.316) records that "Although he often planned photographs in meticulous detail, cropping in the darkroom played an important part in his finished prints. Even when supplying magazines with work Brandt was adamant that the pictures should be published as he supplied". Elsewhere Warburton ('Bill Brandt's Cathedral Interiors', p.265-266) also notes that at least one of the contact prints in the National Buildings Record series has similarly "been cropped down with scissors, presumably by Brandt."

14). See Michael Hallett, *The Real Story of Picture Post*, Birmingham, The Article Press, 1994.

15). See Martin Gasser, 'Bill Brandt in Switzerland and Austria, Shadows of Life', *History of Photography*, vol.21 no.4, Winter 1997, p.303-313.

16). Warburton, 'Brandt's Pictorialism', p.3.

17). 'Bill Brandt, Today and Yesterday', *Photography*, vol.14, no.6, p.20.

18). This image is reproduced in Ian Jeffrey, *Bill Brandt Photographs 1928-1983*, p.168.

19). Richard Sadler has noted that the photograph of the father and child is artificially lit. It is interesting that Ian Jeffrey (*Bill Brandt, Photographs 1928-1983*, p.161) suggests that Brandt's indoor nudes, which he began making in 1944, are "women from the shadows, more especially women of the lighting systems of such Alfred Hitchcock films as *Suspicion* (1941)…"

20). Bill Brandt, *Camera in London*, London, Focal Press, 1948, p.12.

21). See for example Charles Hagen, 'Bill Brandt's Documentary Fiction', *Art Forum*, no.24, Summer 1985, p.111-114; John Taylor 'Picturing the Past, Documentary Realism in the 1930s', *Ten·8*, no.11, 1983, p.15-31 and Nigel Warburton, 'Authentic Photographs', *British Journal of Aesthetics*, vol.37 no.2, April 1997, p.129-137.

22). Bill Brandt, *Camera in London*, London, Focal Press, 1948, p.15.

23). Bill Brandt, *Camera In London*, p.12.

24). Norman Hall, 'Bill Brandt/True Londoner'. Introduction to the exhibition catalogue *Bill Brandt*, New York and London, Malborough Gallery, 1976.

25). An account of the Trust's work can be found in *Sixty Years of Planning, The Bournville Experiment*, Birmingham, Cadbury Brothers, 1942.

26). 'Foreword', *Sixty Years of Planning*, p.1

27). These Minutes form part of the Bournville Village Trust Archives held in the City Archives, Birmingham Central Library.

28). Bournville Village Trust, Quarterly Minutes 1939, No.445, 10 January 1939.

29). Bournville Village Trust, Quarterly Minutes 1939, No. 468, 18 July 1939.

30). See A.H. David, *A Short History of the Birmingham Improvement Scheme*, Birmingham, City of Birmingham, 1890. Burgoyne's photographs form part of the collections held at Birmingham Central Library. It is interesting – though possibly

misleading – to note that the name of the cameraman on the BVT film *When We Build Again* was J.Burgoyne-Johnston.

31). See *Reconditioning Slum Properties, Some Birmingham Schemes*, Publication Department, Bournville, 1936. A fuller account of the history of the series of improvement schemes carried out in Birmingham can be found in Carl Chinn, *Homes for People, 100 years of Council Housing in Birmingham*, Birmingham, Birmingham Books, 1991.

32). 'Pull Down the Slums' *Weekly Illustrated*, 17 November 1934, p. 14-15.

Michael Hallett ('The Lost Brandts', *British Journal of Photography*, 24 March 1994, p. 12) states that "contrary to popular folklore, he (Brandt) was not commissioned" for this story. "According to Stefan Lorant – creator and editor of *Weekly Illustrated*, *Lilliput* and *Picture Post* – the photographer for this particular story was Kurt Hübschmann."

33). See John Taylor, 'Picturing the Past, Documentary realism in the 1930s', *Ten·8*, no.11, 1983, p.15-31.

34). See Humphrey Spender, *'Lensman' Photographs 1932-52*, London, Chatto & Windus, 1987.

35). Harold King, 'Birmingham', *Picture Post*, 21 January 1939, p.44.

36). 'Birmingham', p.48.

37). 'Enough of All This', *Picture Post*, vol.12 no.13, 1 April 1939, p.54-57.

38). Warburton, 'Brandt's Pictorialism', p.6-7. Warburton suggests that Brandt's earlier images of the East End published in *A Night in London* made him the natural choice to illustrate this *Picture Post* feature.

39). Lord Balfour of Burleigh, 'Foreword', *When We Build Again*, London, George Allen & Unwin, 1941, p.vii.

40). See also Lord Addison, 'What Happened in 1918: Why We Must Plan Our Post-War Future Now, *Picture Post*, vol. 19 no. 8, 22 May 1943, pp.20-24.

41). It was not common practice to credit photographers at this time.

42). See 'When We Build Again, A Study Based on Research into Conditions of Living and Working in Birminghgam', *Town and Country Planning*, vol. IX no.36, Winter 1941-42, p.141-147.

43). Ian Jeffrey (*Bill Brandt Photographs 1928-1983* p.176) suggests that a feature published in *Weekly Illustrated*, 2 February 1943 p.14-15, titled 'Changing Britain', about Paul Rotha's new film *The Face of Britain*, which included images of factories and back-to-back housing, was "relevant to Brandt's photography 1934-1938".

44). Paul Rotha, 'Films for Planning', *Town and Country Planning*, vol. IX no35, Autumn 1941, p.89.

45). Mark Haworth-Booth ('Portraits' in *Bill Brandt: Behind the Camera. Photographs 1928-1983* p.40-42) describes how Brandt's 'serious portraiture began with a feature for *Lilliput* in December 1941" called "Young Poets of Democracy" which included a portrait of Dylan Thomas. This was subsequently republished in as picture essay called 'An Odd Lot' in *The Bedside Lilliput*, 1950, p.99.

46). 'When We Build Again, The Film and the Exhibition', *Town and Country Planning*, vol. XI no. 42, Summer 1943, pp.72.

47). See 'Model Town by Thomas Sharpe', *The Architects' Journal*, 4 February 1943, p.93-94.

48). 'When We Build Again Exhibition Tour in the London Area', *Town and Country Planning*, vol. XI vo. 44, Winter 1943, p.184. No less a figure than Sir William Beveridge performed the opening ceremony when the exhibition was shown at Heal & Son Ltd. in the winter of 1943.

49). The Archbishop of York, 'Should the Church Keep Out?', *Picture Post*, 24 April 1943, p.20-21.

50). Cadbury Brothers Limited, *Our Birmingham, The Birmingham of our Forefathers and the Birmingham of our Grandsons*, Bournville, Birmingham, 1943. This was a highly popular publication and was reprinted in May and September 1943. A second edition, published in 1950 went into two printings, the latter of which, published in 1951 included revised and re-set text and many new illustrations.

51). Cadbury Brothers, *Changing Britain, Illustrating the Industrial Revolution: 1750-19..?*, Cadbury Brothers Limited, Bournville, Birmingham, 1943.

52). In her review of *Our Birmingham* (Town and Country Planning, vol. XI No42, p.91) Jean Mann noted "As a Scot, I acknowledge it the finest bargain for a shilling in the realms of Planning literature, and publications. Something really worthwhile!"

53). One of these images, that of a street of back-to-back houses, appears to have been altered between its use in the two publications. In the first, a dog can be seen in the foreground, whilst in the latter, the dog has disappeared. The dog re-appears when the image is used in *Changing Britain*.

54). An introductory note in the book expresses the desire that the "visual presentation will provide a vivid supplement to the regular text books - a mental scaffolding as it were, which will help readers to grasp more clearly the essentials of recent and contemporary changes and to take a greater interest in shaping the future of our cities."

55). 'Unchanging London', *Lilliput*, vol. 4 no.5, May 1939, pp.485-500. In this photo-story 9 of Brandt's photographs of London are juxtaposed with 7 of Doré's engravings.

56). See Jay and Warburton, *The Photography of Bill Brandt*, p.71.

57). In the 1966 edition it is listed as print 42c 'A Sheffield Back Yard'. In the 1977 edition it appears as print 44c under the same title.

58). Ian Jeffrey (*Bill Brandt Photographs 1928-1983*, p. 185-186) has listed the "*Picture Post* features illustrated by Brandt's photographs" from this period.

59). *Daily Mail book of Post-War Homes, based on the ideas and opinions of the Women of Britain*, compiled by Mrs M. Pleydell-Bouverie, London, The Daily Mail Ideal Home Exhibition Department of Associated Newspapers, 1941, p.17.

60). 'Brandt', Email, Sarah McDonald to Peter James, 5 February 2004.

61). For example, see 'The R.I.B.A. Exhibition "Rebuilding Britain", *Journal of the Royal Institute of British Architects*, February

1943, p.75-76; 'Rebuilding Britain', *The Architect and Building News*, 5 March 1943, p.176-179; and *Rebuilding Britain*, London Percy Lund, Humphries and Co., 1943. For further details of related publications see also Selected Bibliography.

62). Ian Jeffrey, *Bill Brandt Photographs 1928-1983*, p.10.

63). Rupert Martin, *'War Work'*, exhibition catalogue, London, The Photographer's Gallery, 1983.

64). Nigel Warburton, *'Brandt's Cathedral Interiors'* p.263.

65). In the 'Acknowledgements' to *When We Build Again* (p.v) it is reported that "this book has been produced under the exigencies of war which have naturally limited the nature and character of permissible maps and photographs.'

66). Ian Jeffrey, *Bill Brandt Photographs 1928-1983*, p.12.

67). Ian Jeffrey, *Bill Brandt Photographs 1928-1983*, p.10, suggests that "the importance of his own concealed agendas made Brandt a poor servant" of those who commissioned him. In a recent Email Michael Hallett ('Brandt and Lorant, Email to Peter James 5 February 2004) confirms this theory. He wrote " It would have been around the time that the lost Brandt's resurfaced that I talked with Stefan Lorant creator and editor of *Picture Post* (from the first issue in October 1938 until he left for the USA on July 20, 1940) about his recollection of Bill Brandt. Lorant was obviously not impressed with Brandt. Pressed further he acknowledged he would use individual photographs from Brandt's portfolio and these were good but he could not rely on Brandt to fulfil an assignment and hit à deadline."

68). Sir Alexander MacGregor, 'Glasgow's Housing Problems', *Town and Country Planning*, Summer 1945, p. 61-64. The image on page 62 was taken in Birmingham whilst photographing children playing in the street (see B.S.3 & 4), and that on page 64 is of a child on a see-saw on the Kingstanding Estate (3.F.W.4).

69). Nigel Warburton, 'Brandt's Pictorialism', p.1.

70). 'Huge Brandt cache comes to light' *British Journal of Photography*, 3 February 1994, p.4.

71). See Peter James, 'The Evolution of the Photographic Record and Survey Movement, c1890-1910', *History of Photography*, vol.12 no.3, July-September 1988, p.205-218. The NPRA Archive was initially presented to the British Library. It is now held in the the V&A.

72). Jonathan Jones, 'The Joy of Gore', *The Guardian Review*, 7 February 2004, p.18.

73). David Hockney used this phrase in an udated quote that appears at the front of Bill Jay and Nigel Warburton's book *The Photography of Bill Brandt*, published in 1999. Here Hockney, speaking about Brandt's pictures of the North of England says "Brandt made pictures of the North of England around the time I was born. They are carefully composed and seem to me very real. I say he made the pictures (rather than take them) because he regarded the image as the important thing, rather than the purity of the execution. His techniques understand the power of images. It's this that, for me, gives them their strength in a time when the photograph as documentary evidence is fading fast. They survive and enter the memory because they were constructed by an artist".

Richard Sadler also used this phrase as the title for his article that appeared in an edition of *Contemporary Photography* (The Newsletter of the Contemporary Group of the Royal Photographic Society, no.22, Spring/Summer) in 2001.

74). The West Midland Group on Post-War Reconstruction and Planning, *Conurbation, A Planning Survey of Birmingham and the Black Country*, London, The Architectural Press, 1948.

75). Paul Cadbury, *Birmingham Fifty Years On*, Birmingham, Bournville Village Trust, 1952.

76). See Nick Hedges, 'A Narrow Road' *Ten·8*, no 5/6, Spring 1981, p.11-15. Hedges himself cites James Agee and Walker Evans' book *Let Us Now Praise Famous Men* as having sustained his convictions about documentary practice.

76). Nick Hedges' Shelter photographs are held by Birmingham Central Library and the National Museum of Photography, Film and Televison.

Selected Bibliography

BOOKS

Reconditioning Slum Properties, Some Birmingham Schemes, Publication Department, Bournville, 1936.

Bill Brandt, *The English at Home,* introduction by Raymond Mortimer, London, B.T. Batsford, 1936.

George Orwell, *The Road to Wigan Pier,* London, Victor Gollancz Ltd., 1937.

Wal Hannington, *The Problems of the Distressed Areas,* London, Victor Gollancz, 1937.

Various Authors, Forward by Lord Balfour of Burleigh, *When We Build Again,* Birmingham, London, George Allen and Unwin, 1941.

Ralph Tubbs, *Living in Cities,* London, Armsworth, 1942.

Mass Observation, *People's Homes,* London, John Murray, 1942.

Clough William Ellis, *Plan for Living,* London, Town and Country Planning Association (part of the Rebuilding Britain Series), 1943.

Sixty Years of Planning: The Bournville Experiment, Birmingham, Bournville Village Trust, 1942.

R.I.B.A, *Rebuilding Britain,* London, Percy Lund & Co. 1943.

Planning for Reconstruction, London, The Architectural Press, 1943.

Ed. F.E. Townrow, *Replanning Britain,* London, Town and Country Planning Association, 1943.

Ed., Mrs. M. Pleydell-Bouverie, *The Daily Mail Book of Post War Homes, based on the ideas and opinions of the Women of Britain and specially compiled for the Daily Mail,* London, Daily Mail Ideal Home Exhibition Department, 1943.

Phoebe Pool and Flora Stephens, *A Plan for Town and Country,* London, Pilot Press, 1944.

Cadbury Brothers, *Our Birmingham, The Birmingham of our Forefathers and the Birmingham of our Grandsons,* Birmingham, Cadbury Brothers, 1943.

Cadbury Brothers, *Changing Britain, Illustrating the Industrial Revolution: 1750- 19..?,* Birmingham, Cadbury Brothers, 1943.

Bill Brandt, *Camera in London,* London, The Focal Press, 1948.

Bill Brandt, *Shadow of Light, A collection of photographs from 1931 to the present,* with an introduction by Cyril Connolly and notes by Marjorie Beckett, London, The Bodley Head, 1966.

Bill Brandt, *Shadow of Light,* Revised and extended edition, Introduction by Mark Haworth-Booth, London, Gordon Fraser, 1977

Michael Hiley, *Bill Brandt: Nudes 1945-1980,* London, Gordon Fraser, 1980.

Bill Brandt, *London in the Thirties,* London, Gordon Fraser, 1983.

Bill Brandt, *Behind the Camera, Photographs 1928-1983,* Introduction by Mark Haworth-Booth, Essay by David Mellor, Oxford, Phaidon, 1985.

Carl Chinn, *Homes for People, 100 Years of Council Housing in Birmingham,* Birmingham, Birmingham Books, 1991.

Michael Hallett, *The Real Story of Picture Post,* Birmingham, The Article Press, 1994.

Ian Jeffrey, *Bill Brandt Photographs 1929-1983,* London, Thames and Hudson, 1993.

Bill Jay and Nigel Warburton, *The Photography of Bill Brandt,* London, Thames and Hudson, 1999.

ARTICLES

'Enough of All This', *Picture Post,* vol.2 no.13, 1 April 1939, p.54-57.

'Unchanging London', *Lilliput,* May 1939.

'A Plan for Britain', *Picture Post,* vol.10 no.1, 4 January 1941.

Paul Rotha, 'Films for Planning' *Town and Country Planning Quarterly Review,* Autumn 1941, p.87-89.

'When We Build Again, A Study Based on Research into Conditions of Living and Working in Birmingham', *Town and Country Planning Quarterly Review,* Winter 1941-42, p.141-146.

'A Post-War Kitchen', *Town and Country Planning Quarterly Review,* vol. XI January-April 1943, p.29.

Clough William Ellis, 'What Have We Done to Our Country', *Picture Post,* vol.13 no.1, 3 January 1942, p.13-17.

'Planning in Pictures', *Town and Country Planning Quarterly Review,* Winter 1942-43, p.139-140.

Julian Huxley, 'Changing Britain: What is Her Future?, *Picture Post,* vol.18 no.1, 2 January 1943, p.7-10.

'When We Build Again, The Film and Exhibition', *Town and Country Planning Quarterly Review,* Spring 1943, p.72-73.

Bournville Trust Film pre-view', *The Architect's Journal,* 11 March 1943, p.179.

'A Town in Model Form', *The Architect and Building News,* 5 February 1943, p.118-119.

Sir William Beveridge, The Opening of the "Rebuilding Britain" Exhibition', *Journal of the Royal Institute of Architects,* March 1943, p.99-102.

The Archbishop of York, 'Should the Church Keep Out?', *Picture Post,* vol.19 no.4, 24 April 1943, p.20-21.

Lord Addison, 'What Happened in 1918: Why We Must Plan Our Post-War Future Now', *Picture Post,* vol.19 no.8, 22 May 1943, p.20-24.

Edward Hulton, 'The Fruits of Victory', *Picture Post,* vol.20 no.9, 28 August 1943, p.26.

'When We Build Again, The Film and the Exhibition', *Town and Country Planning Quarterly Review,* Summer 1943, p.72-73.

'When We Build Again Exhibition, Tour in the London Area', *Town and Country Planning Quarterly Review,* Winter 1943-44. p.184-185.

'How to Plan Your Town', *Picture Post,* vol25.no.5, 28 October 1944, p.17-26.

'What It Means to Live in a Good House', *Picture Post,* vol.22 no.1, 1 January 1944, p.22.

'What It Means to Live in a Not-So-Good-House', *Picture Post,* vol.22 no.1, 1 January 1944, p.23.

R. L. Reiss, 'Edinburgh, Plymouth and Birmingham, Post-War Proposals with an Epilogue on Density', *Town and Country Planning Quarterly Review,* Summer 1944, p.62-72.

'A Plan For Housing', *Picture Post*, vol.28 no2, 14 July 1945.Special Issue.

Sir Alexander MacGregor, 'Glasgow's Housing Problems', *Town and Country Planning*, Summer, 1945, p.61-65.

Dr. J.J. Mallon, 'The Doomed East End' (with photographs by Charles H. Hewitt and Bill Brandt), *Picture Post*, vol.30 no.10, 9 March 1946, p.8-11.

Max Lock, 'Town Planning and Public Relations', *Town and Country Planning Quarterly Review*, Autumn 1946, p.110-114.

'The Forgotten Gorbals', *Picture Post* (with Photographs by Bill Brandt and Bert Hardy), vol.38 no.5, 31 January 1948, p.11-16.

Nick Hedges, 'A Narrow Road', *Ten·8*, no. 5/6 Spring 1981, p.11-17.

John Taylor, 'Picturing the Past, Documentary Realism in the 30s', *Ten·8*, No.11, 1983, p.15-31.

Charles Hagen, Bill Brandt's Documentary Fiction, *Art Forum*, Summer 1985, p.111-114.

Nigel Warburton, 'Bill Brandt's Cathedral Interiors, Rochester and Canterbury', *History of Photography*, vol. 17, no. 3. Autumn 1993, p.263-268.

Richard Sadler, 'Bill Brandt, Photographs 1904-1983', *Contemporary Photography*, Newsletter of the Contemporary Group of the Royal Photographic Society, Issue 7, Winter 1993, p.45.

'Huge Brandt cache comes to light', *British Journal of Photography*, 3 February 1994, p.4.

Terry Grimley, 'Uncovered: A day in the life of the Second City', *Birmingham Post*, 8 February 1994, p.14.

Eddie Marsman, 'Onbekende foto's van Bill Brandt in archief ontdekt', *NRC Handelsblad*, 4 March 1994, p.7.

Michael Hallett, 'The lost Brandts', *British Journal of Photography*, 24 March 1994, p.12-13.

Eddie Marsman, 'Onbekende foto's van Bill Brandt ontdket', *Foto Magazine*, June 1994, p.66-67.

Chris Upton, 'When the white heat of technology was put to work in the kitchen', *Birmingham Post*, 25 February 1995, p.20.

Spotlight, *Birmingham Voice*, 8 November 1995, p.7.

'Mary's surprise Brandt photo', *Birmingham Voice*, 22 November 1995, p.3.

Carl Chinn, 'Fit for Heroes', *Evening Mail*, 2 December 1995, p.14-15.

Paul Barker, 'Life Studies', *Independent on Sunday Magazine*, 3 December 1995, p.12-15.

Terry Grimley, 'A glimpse at city's history', *Birmingham Post*, 6 December 1995, p.14.

Peter James, 'The Lost Brandts', *Amateur Photographer*, 23 December 1995, p.62-65.

'New insight into Brandt methods', *British Journal of Photography*, 17 January 1996, p.5.

Paul Stewart, 'Honourable Objectivity', Letters & Comment, *British Journal of Photography*, 24 January 1996, p.9.

Richard Sadler, 'Bill Brandt's Wartime Social Documentary', *The Photographic Journal*, February 1996, p.102-103.

Michael Harrison, 'Reports, Rebuilding the Homefront: A One Day Symposium, Birmingham, 10 February 1996, *Planning History*, vol. 18 no.1, 1996, p.39-41.

Nigel Warburton, 'Authentic Photographs', *British Journal of Aesthetics*, vol. 37 no.2, April 1997, p.129-137.

Martin Gasser, 'Bill Brandt in Switzerland and Austria', *History of Photography*, vol. 21 no.4, Winter 1997, p.303-313.

Richard Sadler, 'Constructed by an Artist', *Contemporary Photography*, Newsletter of the Contemporary Group of the Royal Photographic Society, Spring/Summer 2001, Issue 22. p.12.

SEE ALSO

Bill Brandt, Traveller in a Strange Land. A film made for Arena for the BBC, and broadcast on 4 February 2002

NOTE

In a series of appendices Ian Jeffrey's book, *Bill Brandt Photographs 1929-1983* lists "*Weekly Illustrated*: features relevant to Brandt's photography 1934-38"; "*Lilliput*: a checklist of photography associated with Brandt"; and "*Picture Post* features illustrated by Brandt's photographs".

A detailed list of "Books by and about Bill Brandt", "Articles by Bill Brandt", "Selected photo-stories by Bill Brandt in *Lilliput* and *Picture Post*", "Articles about Bill Brandt", "Selected exhibition catalogues of Bill Brandt's Work", "Books and Exhibition Reviews of Bill Brandt's Work", and "Television and Radio Programmes about Bill Brandt" can be found in *Bill Brandt, Selected texts and bibliography*, edited by Nigel Warburton, Oxford, Clio Press, 1993.